A Turning Point

Images to Words

Photography by Victor Gagliardi

Gagliardi Photo Collection
New York
2001

Nothing about human life is more precious than that we can define our own purpose and shape our own destiny.

—Norman Cousins

It is not true that one picture
 is worth a thousand words.
It only takes a few words—
 if they are the right words.

—Norman Cousins

Gagliardi Photo Collection
39 Hudson Avenue
Nyack, NY 10960
845-358-7031
www.gagliardiphoto.com

© 2001 Gagliardi Photo Collection. All rights reserved.
First Printing July, 2001
Second Printing August, 2002
Third Printing January, 2004
Fourth Printing August, 2006

Library of Congress Catalog Card Number: 2001118309
ISBN: 0-9712687-0-3

Book designed by Peter Lukic, peterlukic@yahoo.com
Printed by Editoriale Bortolazzi-Stei s.r.l., Verona, Italy

Cover photo: *Walkway*

As I sit and review this introduction for the 4th printing, I am very moved that what began with so much uncertainty and risk has after five years assisted so importantly in my growth. It brought my work into peoples lives around the world and expanded my awareness of the world by so many great people coming into mine.

"A Turning Point" is a collection of my photographs accompanied by brief philosophical writings. It is a reflection of my life and work over a period of twelve years. I collected these writings for twenty years from people whose words I found resonating within me. They also challenged my perception of life. The continuity of the book is not in the photographs but is rather achieved by the flow of the passages: one leads to the next. The photographs are there to support the writings, and not the reverse.

This book reflects the process I went through in order to be able to do the work I love. I began capturing images in 1977, and fell in love with my new hobby. In 1989, I sold my first photographs as artwork and two years later I left my career in business to work full-time as a photographic artist. I currently own a gallery in Nyack, NY.

"A Turning Point " blends aesthetics with philosophical wisdom and encouragement for the celebration of life. The words to the right were my outline for the book.

I dedicate the last few pages of this book to the people who have been invaluable in my life and to the people and organizations who have purchased my photographs and supported my career. Without them, there could not have been this turning point.

Victor Gagliardi

The Past

Happiness

Friendship

Love Relationships

Pain & Sorrow

God, Religion, & Death

Making & Building

Work

Achievement

Travel & The World

Ways of Being

The Future

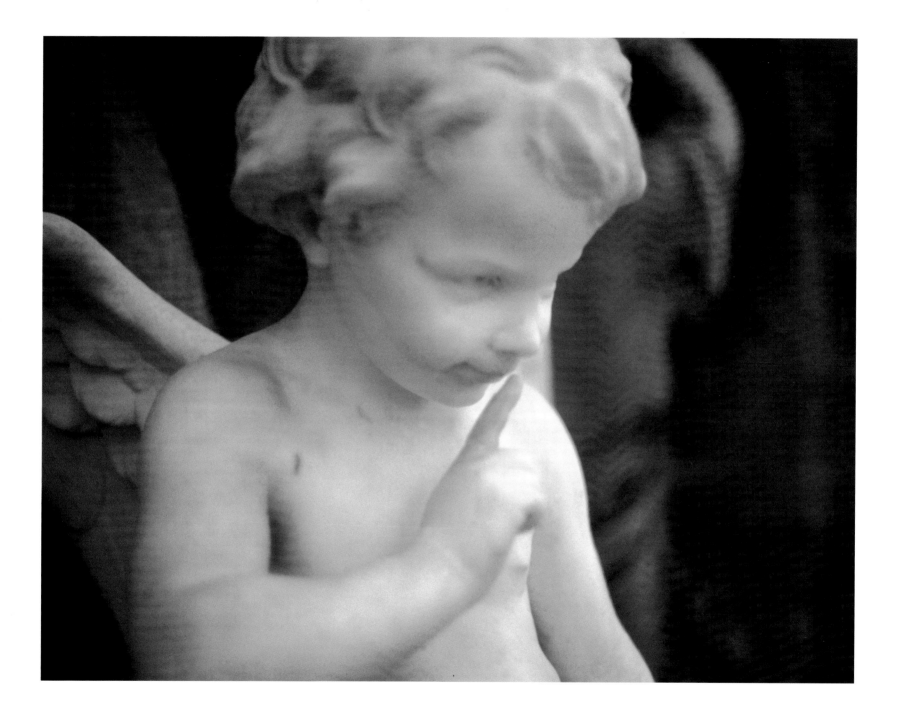

Cherub of the Louvre

It is said, and it is true, that just before we are born
a cavern angel puts his finger to our lips and says,
"Hush, don't tell what you know."
This is why we are born with a cleft on our upper lips
and remembering nothing of where we came from.

—Roderick MacLeish

And do not change.
Do not divert your love from visible things.
But go on loving what is good, simple and ordinary;
animals and things and flowers,
and keep the balance true.

—Rainer Maria Rilke

Dandelion

...Merrily, merrily,
merrily, merrily,
Life is but
a dream.

Rowboat

When I was young, every day
was as a beginning of some new thing,
and every evening ended
with a glow of the next day's dawn.

—Eskimo poem

Meeting in Bodrum #3

Carousel Horse #6

If I had my life to live over,
I would start barefoot earlier in the spring
and stay that way later in the fall.
I would go to more dances.
I would ride more merry-go-rounds.
I would pick more daisies.

—Nadine Stair

You will find as you look back upon your life,
that the moments when you have really lived
are the moments when you have done things
in the spirit of love.

—Henry Drummond

Child with Grapes

A man does not learn to understand anything

unless he loves it.

—Goethe

Tulips Together

I firmly believe that the most important factor is our attitude and human motivation...
genuine human love, human kindness and human affection...
True love or compassion is actually...a strong sense of care and
concern for the happiness of the other; that is genuine love.
Such true love automatically becomes a sense of responsibility.
When we have that kind of love with its strong sense of responsibility,
we will never lose our hope or our determination.

—Tenzin Gyatso, His Holiness,
The Fourteenth Dalai Lama

Turkish Tea

I suddenly thought,
"Well, what did you think it was
that needed to be loved?"
And just like that, the doors opened
and I was in paradise.

—Thaddeus Golas

Palms #2

I am always searching for peace,
but it is the forest fire that forces open the pinecones
that allows for new trees to grow.

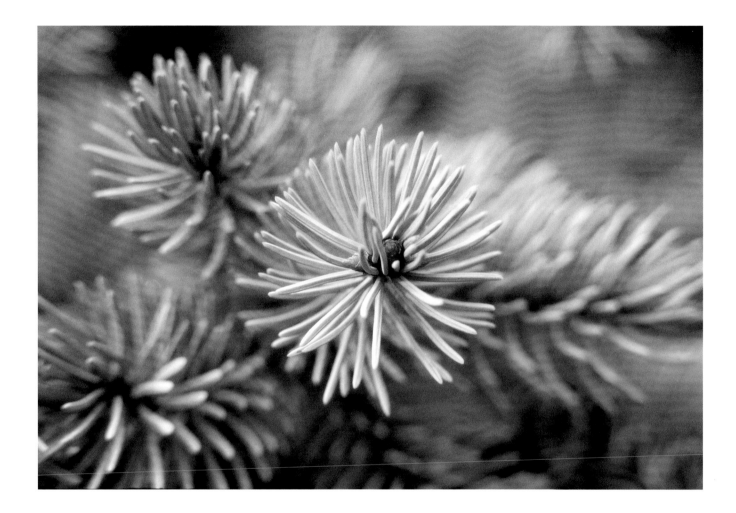

Blue Spruce

Take the emptiness you hold in your arms
And scatter it into the open spaces we breathe.
Maybe the birds will feel how the air is thinner,
And fly with more affection.

—Rainer Maria Rilke

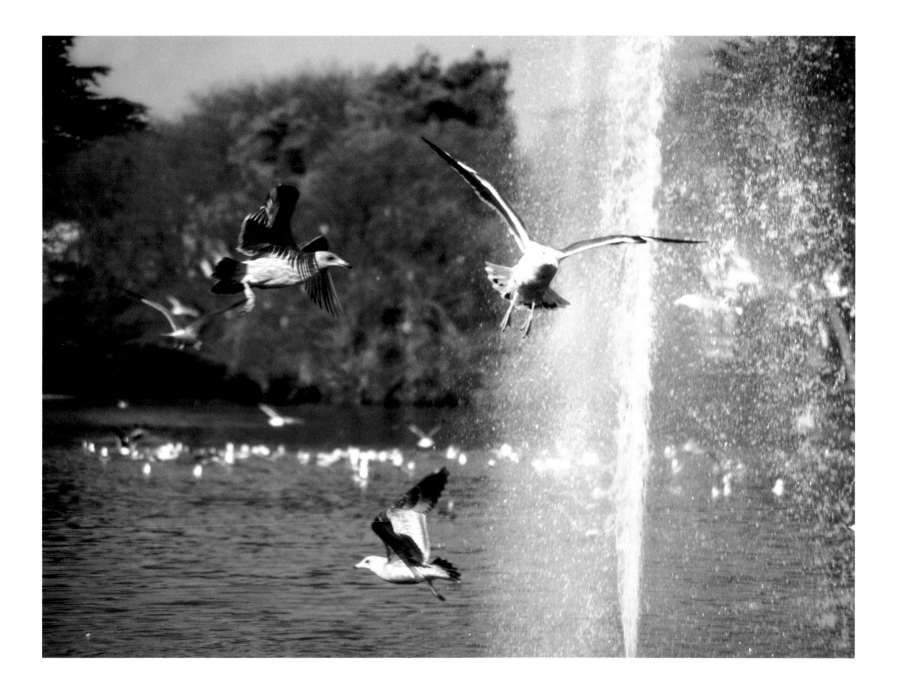

Gulls in Flight

And someday there shall be
such closeness
that when one cries,
the other shall taste salt.

—Unknown

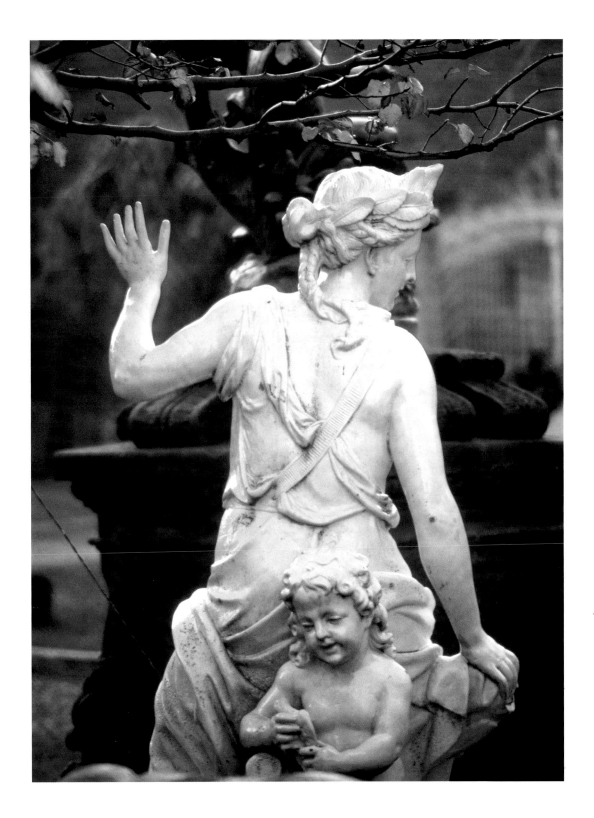

Watching Over

And here is my secret, a very simple secret.
It is only with the heart that one can see rightly;
what is essential is invisible to the eye.

—Antoine De Saint-Exupery

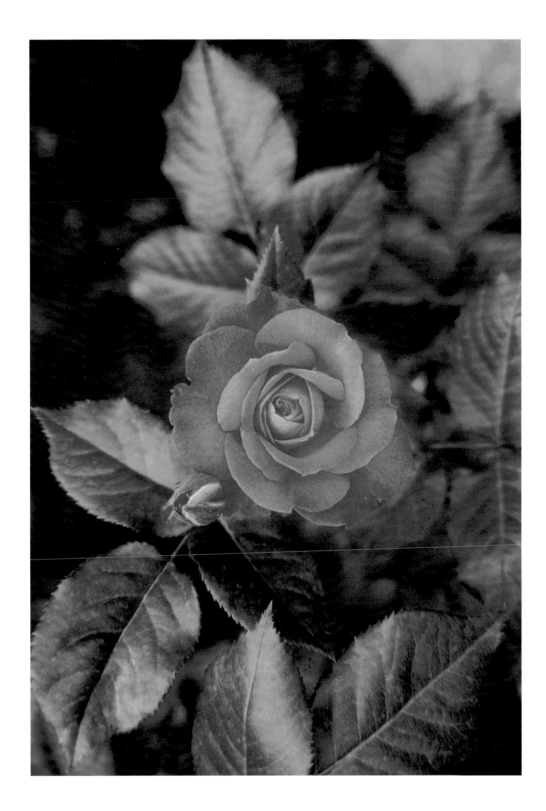

Antique Rose

But let there be spaces
in your togetherness...
For the pillars of the temple
stand apart,
And the oak tree
and the cypress grow
not in each other's
shadow.

—Kahlil Gibran

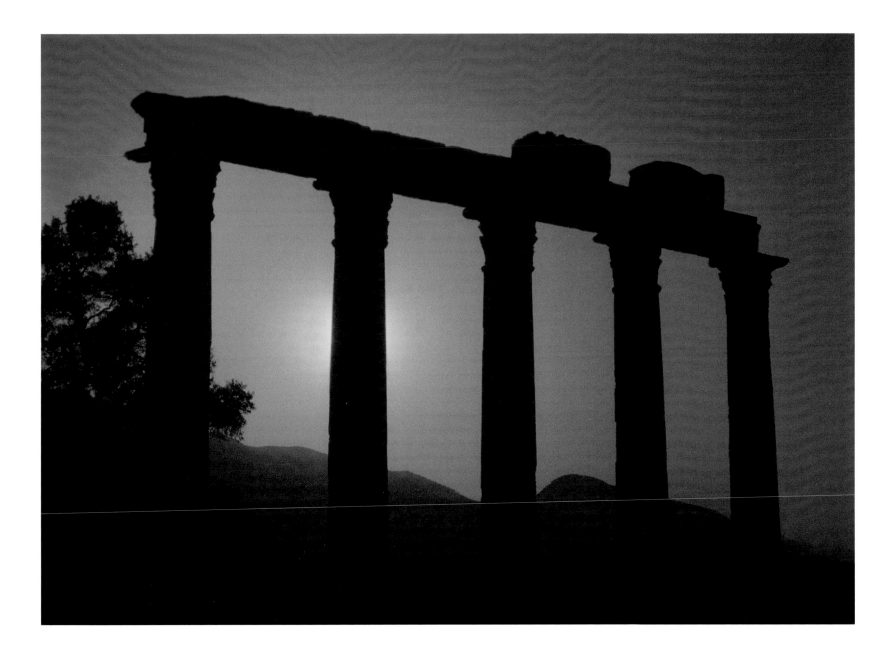

Euromos Temple of Zeus #2

People say that what we're all seeking is a meaning to life...
I think that what we're really seeking is an experience of being alive,
so that our life experiences on the purely physical plane
will have resonance within our innermost being and reality,
so that we can actually feel the rapture of being alive.

—Joseph Campbell

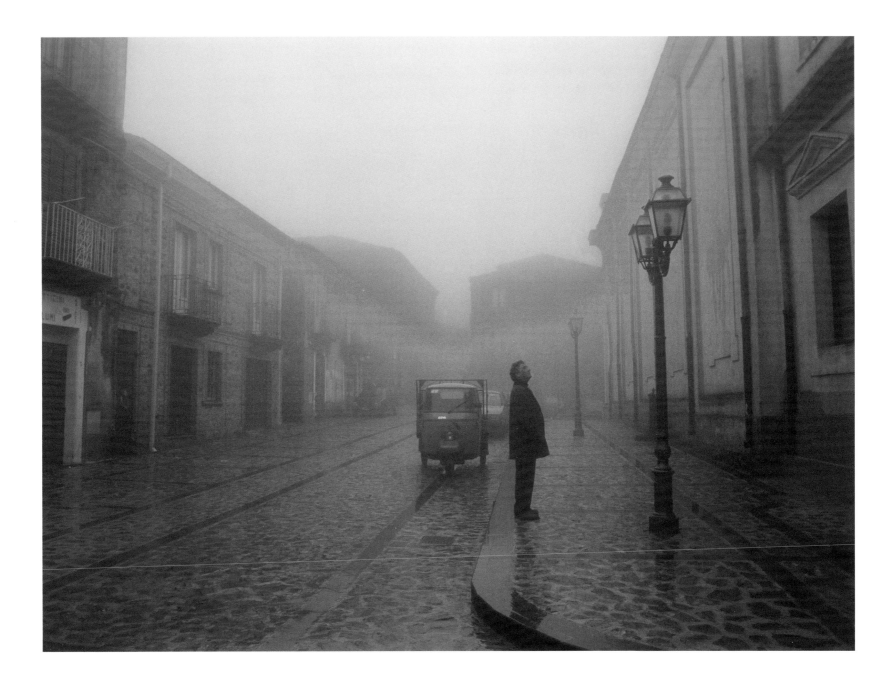

Still Waiting for Juliet

My lifetime

listens to yours

—Muriel Rukeyser

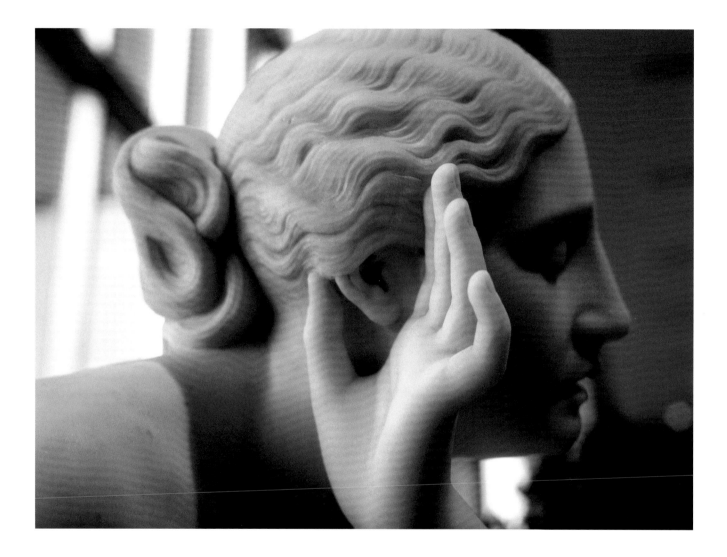

Listen

When you part from your friend, you grieve not;
For that which you love most in him may be clearer in his absence,
as the mountain to the climber is clearer from the plain.

—Kahlil Gibran

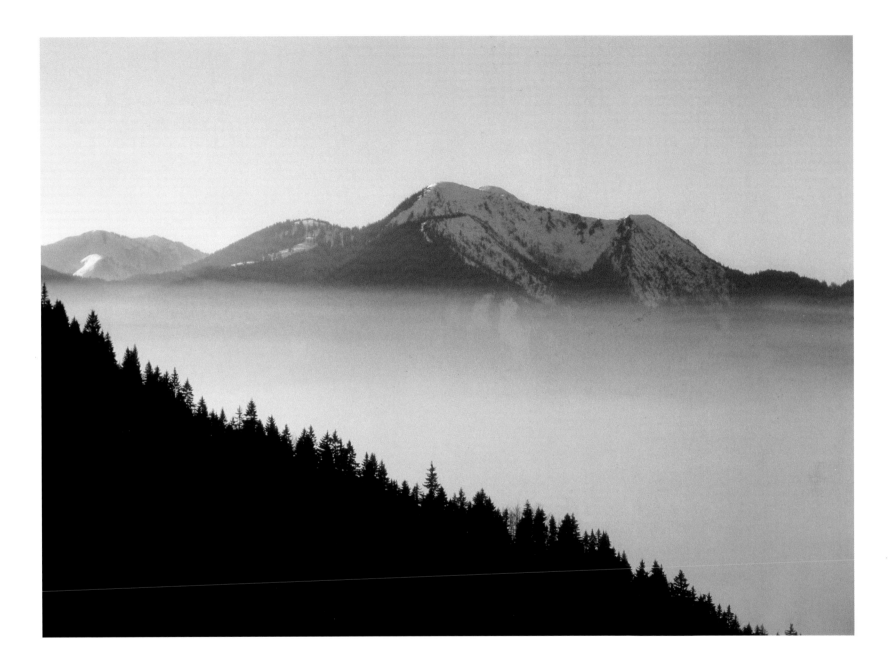

Vanishing Point

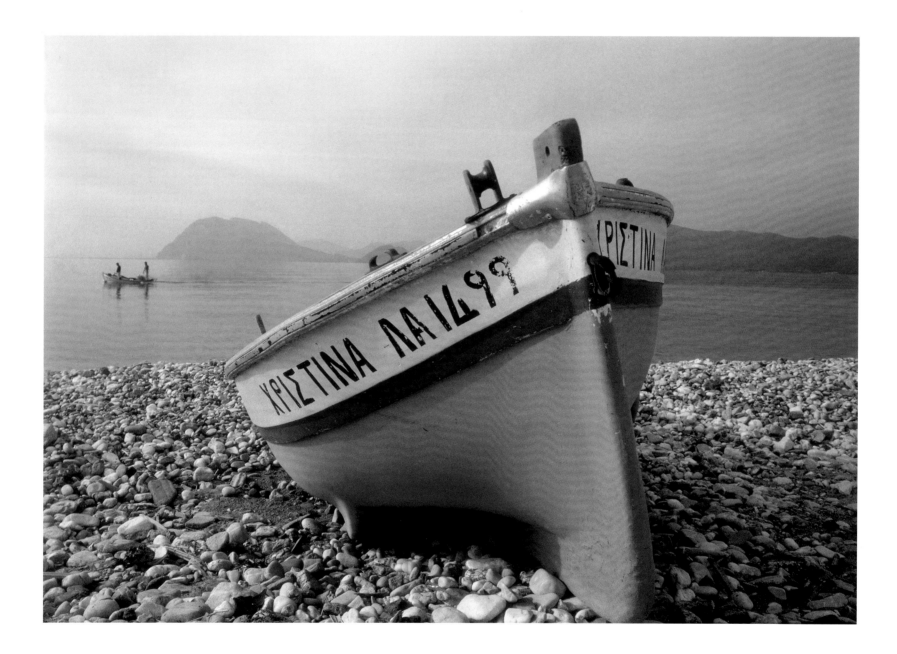

Christina with Fishermen

I live inside this shell
that's inside this box
that's inside this tunnel
that's under the sea
that I hide in to keep away from you.
If you loved me - you'd find me.

—Unknown

One must learn to love,

and go through a good deal of suffering to get to it,...

the journey is always toward the other soul, not away from it.

Do you think that love is an accomplished thing, the day it is recognized? It isn't.

To love, you have to learn to understand the other more than she understands herself,

and to submit to her understanding of you. It is damnably difficult and painful, but it

is the only thing which endures. You mustn't think that your desire or your fundamental

need is to make a career, or to fill up your life with activity, or even provide for your

family materially. It isn't. Your most vital necessity in life is that you shall

love your wife completely and implicitly and in entire nakedness of body

and spirit. Then you will have peace and inner security no matter

how many things go wrong. And this peace and security

will leave you free to act and to produce your own work,

a real and independent workman.

—D.H. Lawrence

...AND
THINK NOT
YOU CAN DIRECT
THE COURSE OF LOVE
FOR LOVE
IF IT FINDS YOU WORTHY
WILL DIRECT YOUR
COURSE...

—Kahlil Gibran

For one human being to love another: that is
perhaps the most difficult of all tasks; the ultimate,
the last test and proof, the work for which
all other work is but a preparation.

—Rainer Maria Rilke

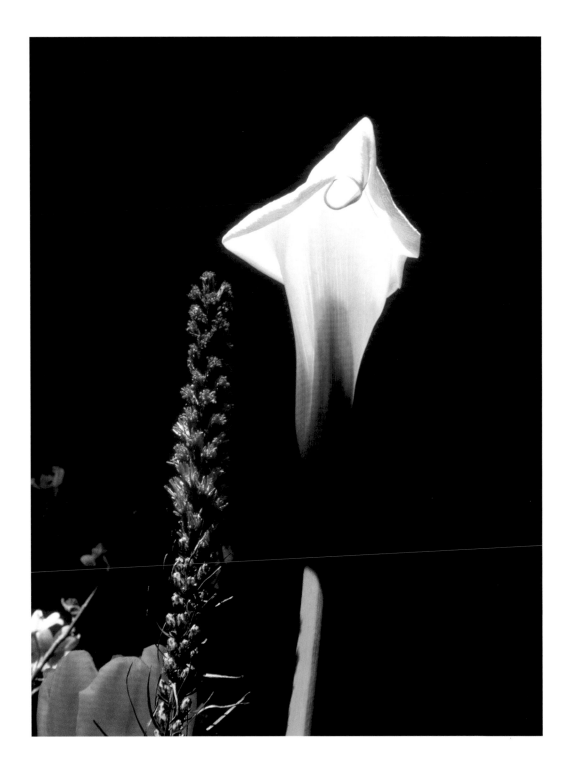

Jill's Calalily

One should only celebrate a happy ending;
celebrations at the onset exhaust the joy and energy
needed to urge us forward and sustain us in the long struggle.
And of all celebrations a wedding is the worst;
no day should be kept more quietly and humbly.

—Goethe

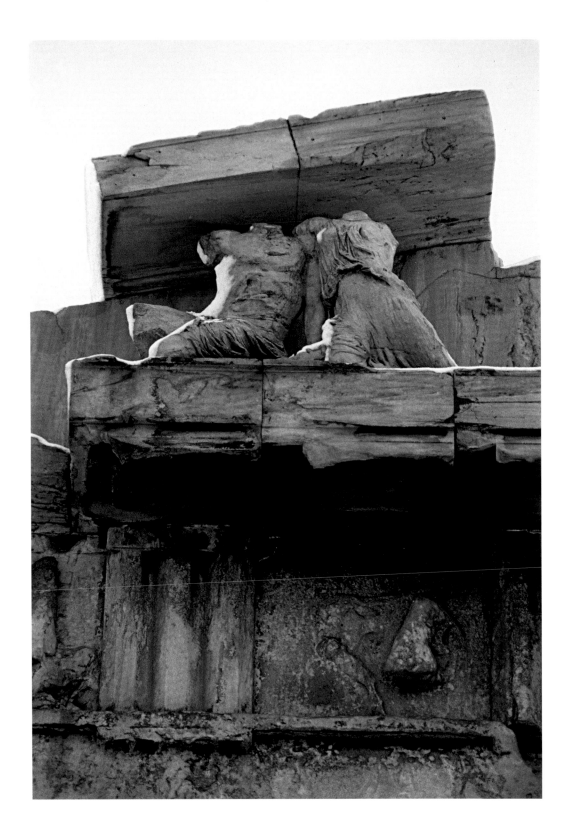

Man and Woman, Parthenon

Every life has a measure of sorrow.
Sometimes it is this that awakens us.

—Jack Kornfield

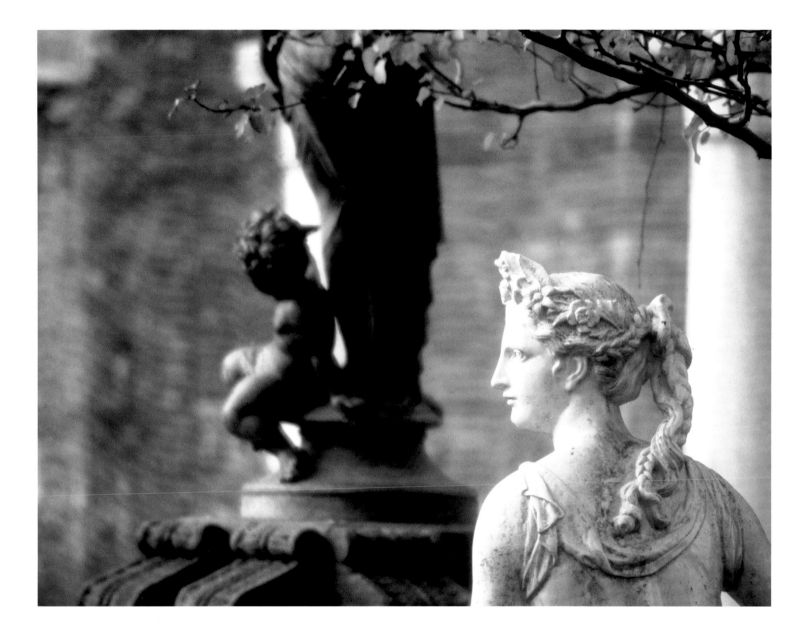

Single Woman

People are like stained-glass windows.
When the darkness sets in,
their true beauty is revealed
only if there is a light from within.

—Elisabeth Kubler-Ross

Stained Glass #2

66 They came for the Communists, and I
didn't object – For I wasn't
a Communist;
They came for the Socialists, and I
didn't object – For I wasn't a Socialist;
They came for the labor leaders, and I
didn't object – For I wasn't a labor leader;
They came for the Jews, and I didn't
object – For I wasn't a Jew;
Then they came for me –
And there was no one left to object. 99

Martin Niemöller, German Protestant
pastor. 1892-1984

We who lived in concentration camps can remember
the men who walked through the huts comforting others,
giving away their last piece of bread. They may have been few in
number, but they offer sufficient proof that everything can be taken
away from a man but one thing: the last of the human freedoms—
to choose one's attitude in any given set of circumstances,
to choose one's own way.

—Viktor Frankl

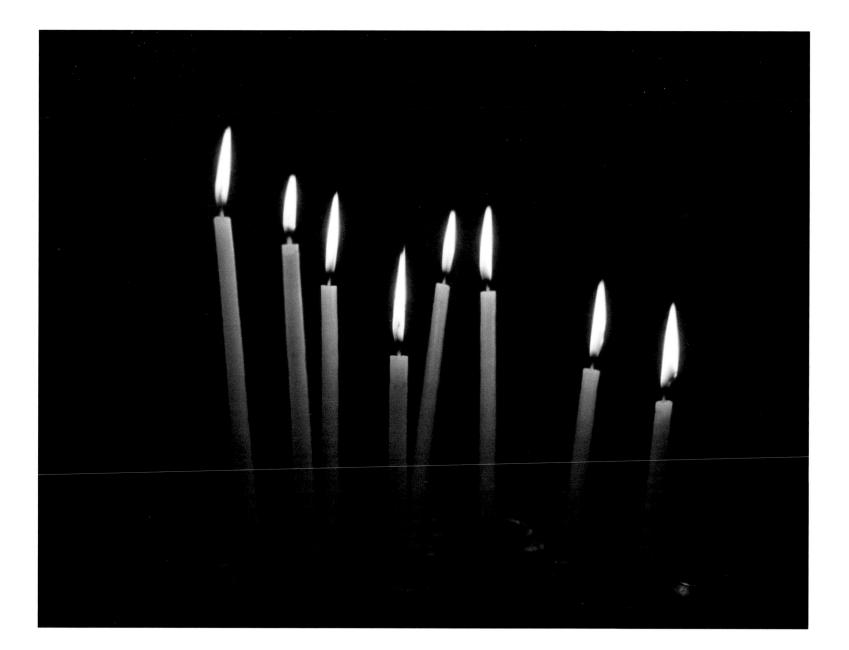

Jerusalem Candles

There is but one freedom, to put oneself right with death. After that everything is possible. I cannot force you to believe in God. Believing in God amounts to coming to terms with death. When you have accepted death, the problem of God will be solved—and not the reverse.

—Albert Camus

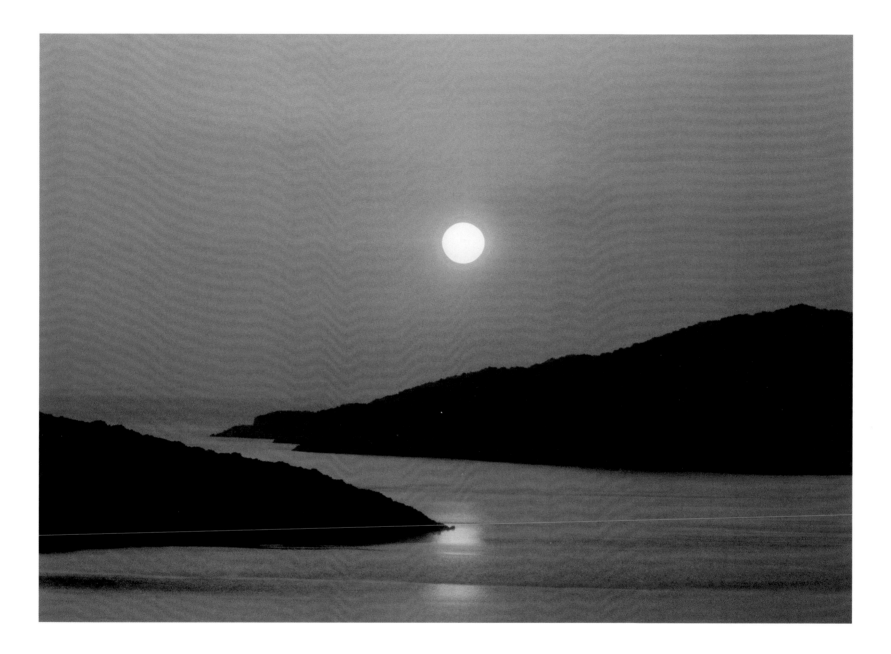

Sun over Kas

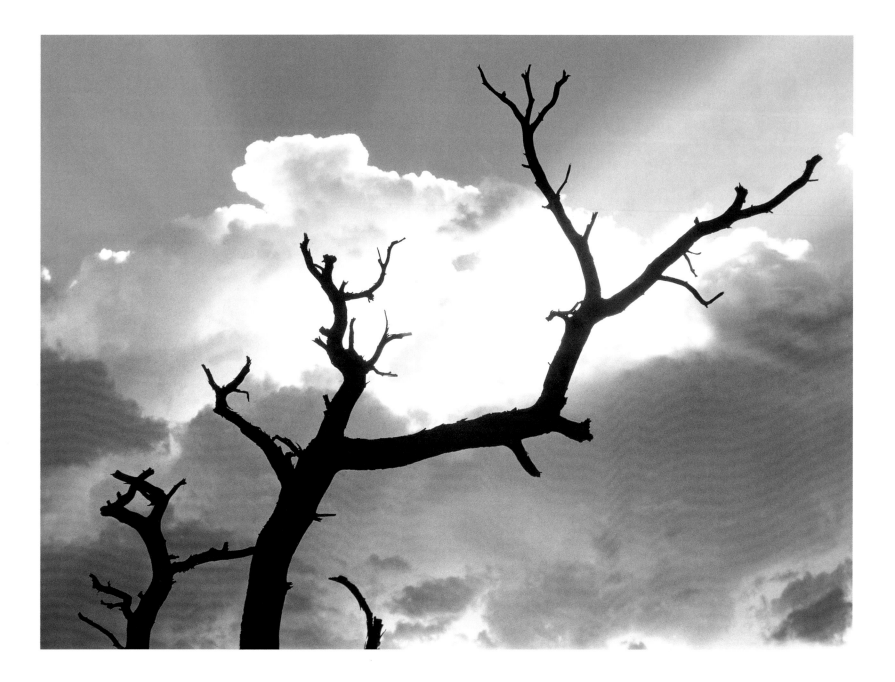

Reaching

Only when you drink from the river of silence
shall you indeed sing.
And when you have reached the mountain top,
then you shall begin to climb.
And when the earth shall claim your limbs,
then shall you truly dance.

—Kahlil Gibran

What makes a saint?
Why were the saints saints?
Because they were cheerful
 when it was difficult to be cheerful.
Because they were patient
 when it was difficult to be patient.
Because they pushed on
 when they wanted to stand still.
And kept silent
 when they wanted to talk.
Were agreeable
 when they wanted to be disagreeable.
That was all.
It was quite simple,
 and always will be.

—Mirian C. Hunter

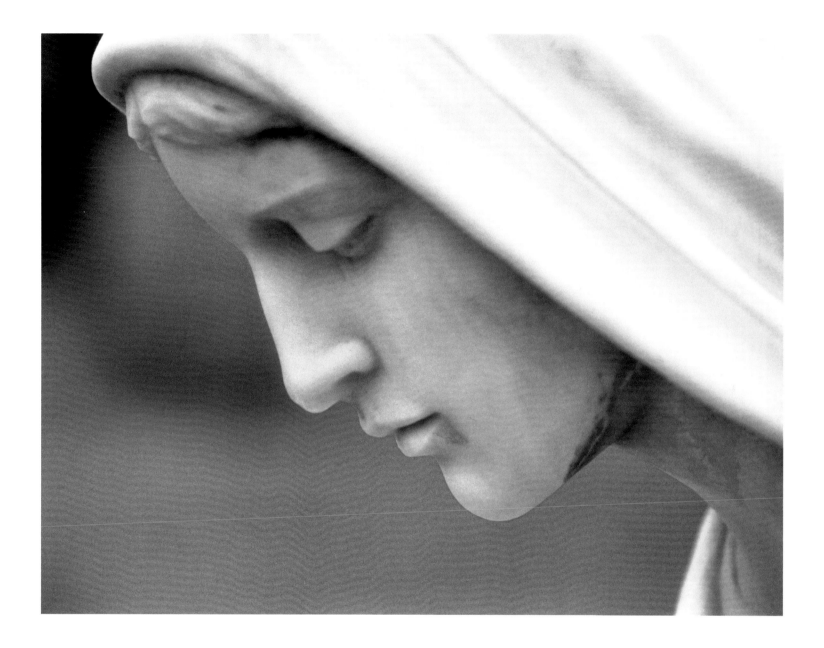

Mary

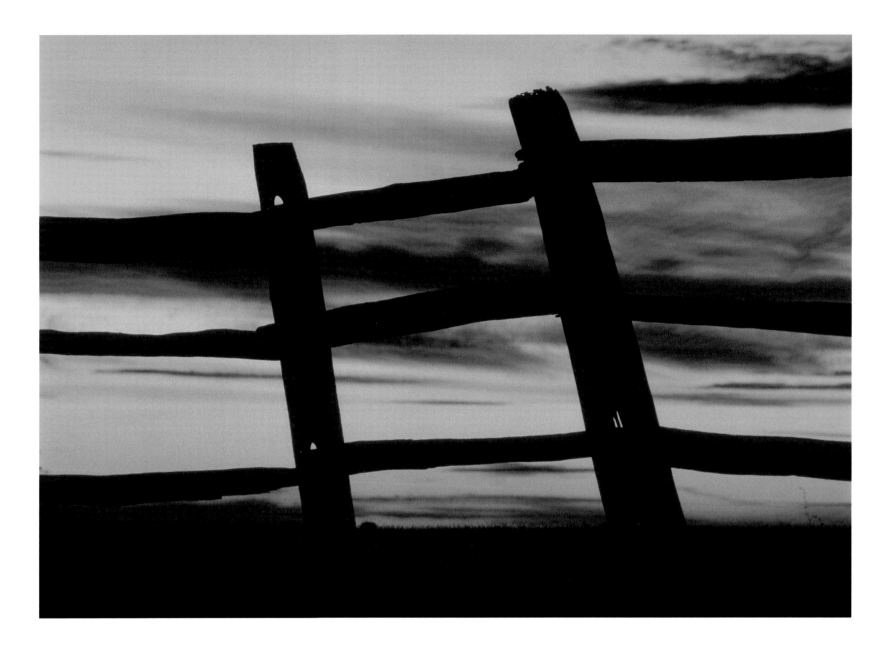

Moving Fence

For a long time it had seemed to me that life was about to begin—
real life. But there was always some obstacle in the way,
something to be got through first, some unfinished business,
time still to be served, a debt to be paid. Then life would begin.
At last it dawned on me that these obstacles were my life.

—Fr. Alfred D'Souza

I should never have made my success in life if I had not bestowed upon the least thing I have ever undertaken the same attention and care that I have bestowed upon the greatest.

—Charles Dickens

Christmas Ornament

Most people build as they live. . . As a matter of routine and senseless accident.
But a few understand that building is a great symbol. We live in our minds,
and existence is the attempt to bring that life into physical reality,
to state it in gesture and form. For the man who understands this,
a house he owns is a statement of his life.

—Ayn Rand

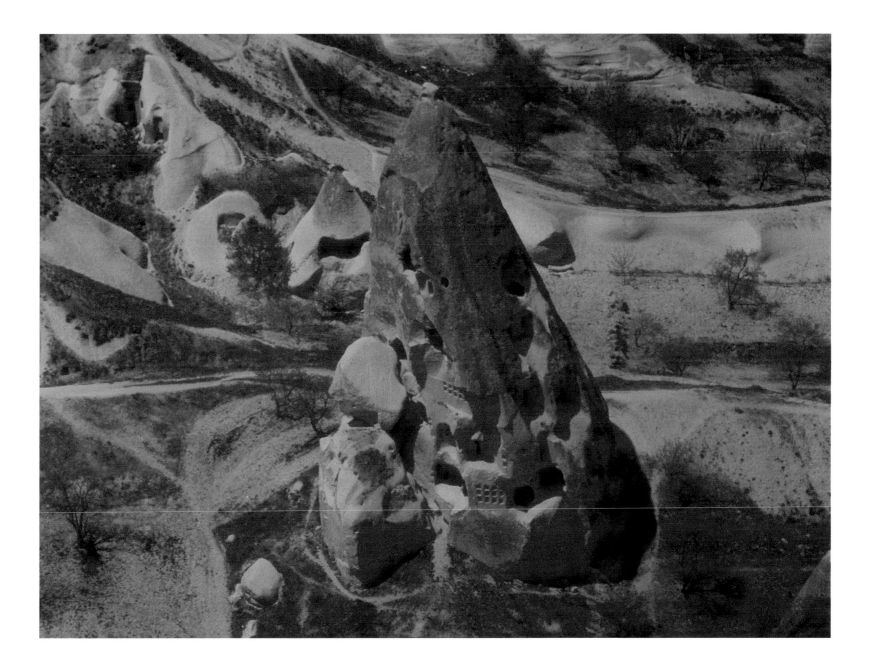

Houses of Capadochia

Do you know what creation is?

It is feu continu (uninterrupted fire).

You simply keep on going,

taking up each day from where you ceased.

What you insist on calling genius in me is artisan.

My father was a shoemaker,

so am I to the last.

—Jean Gionos

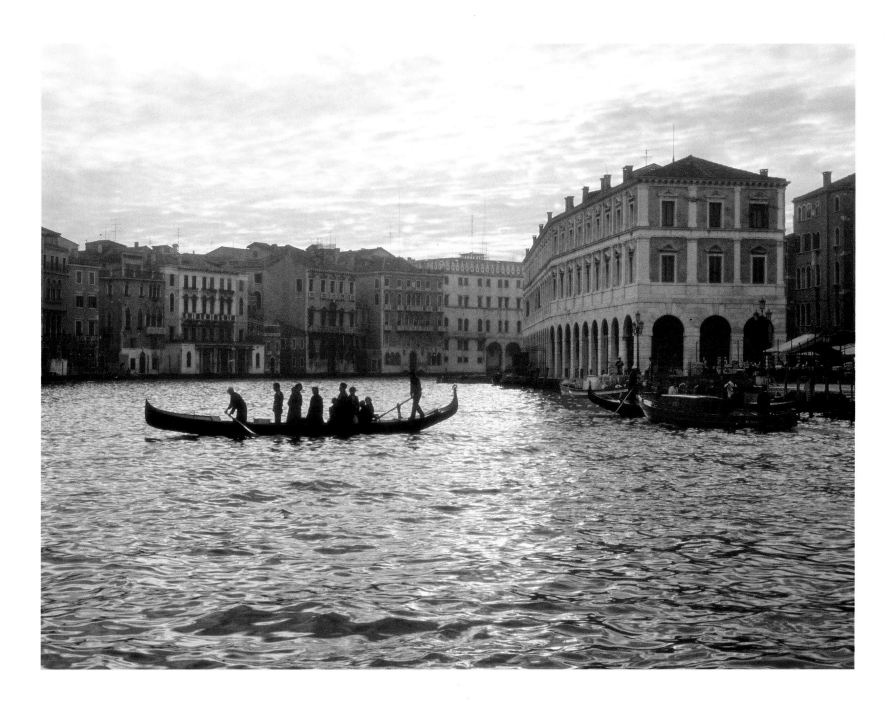

Venice

As a man's real power grows and his knowledge widens,
ever the way he can follow grows narrower:
Until at last he chooses nothing,
but does only and wholly
what he must do.

—Ursula K. Le Guin

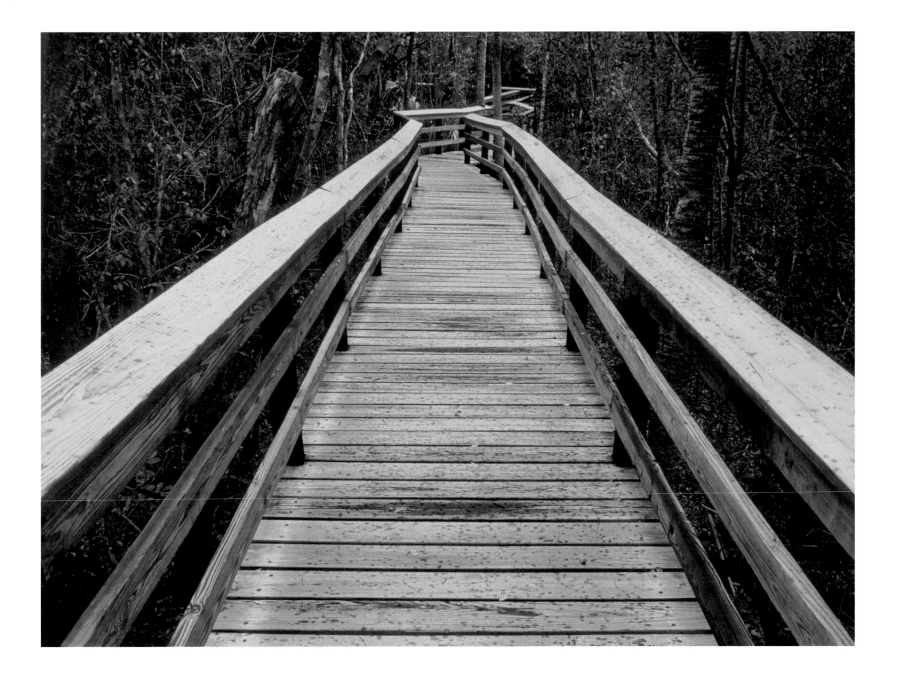

Walkway

Get up and do something useful,

 the work is part of the koan!

—Hakuin

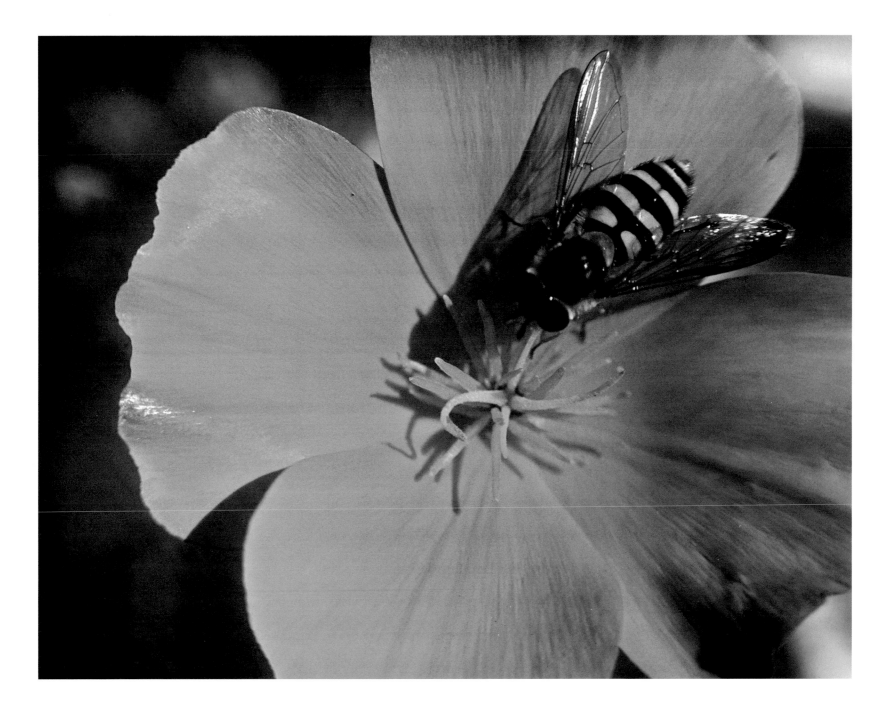

English Bee

Press on.

Nothing in the world can take the place of persistence.

Talent will not; nothing is more common than unsuccessful men with talent.

Genius will not; unrewarded genius is almost a proverb.

Education will not; the world is full of educated derelicts.

Persistence and determination alone are

omnipotent.

—Coolidge

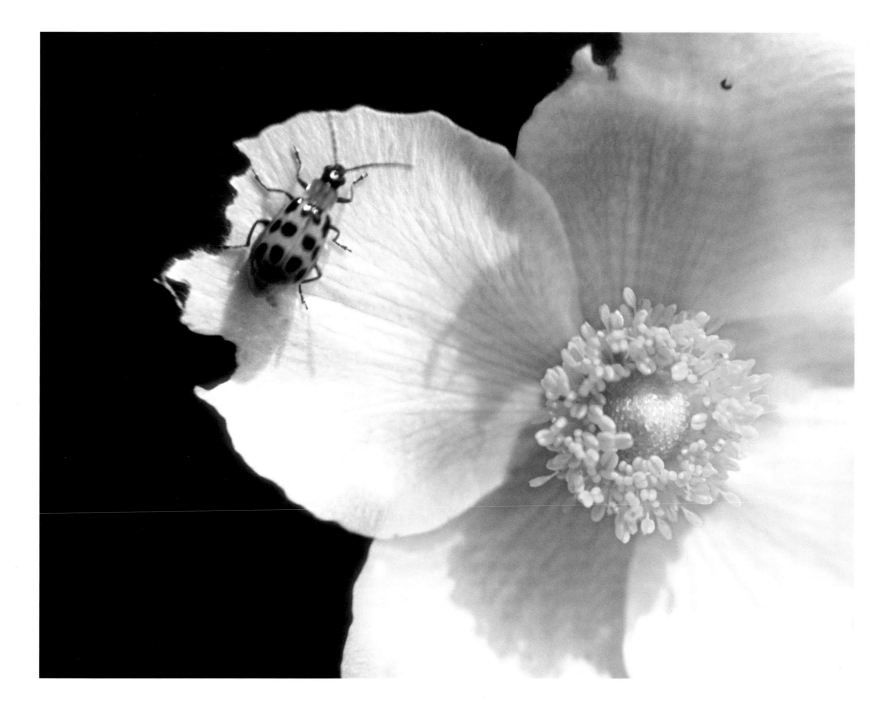

Ladybug

Security is mostly a superstition.
It does not exist in nature, nor do the
children of men as a whole experience it.
Avoiding danger is no safer in the
long run than outright exposure.

—Helen Keller

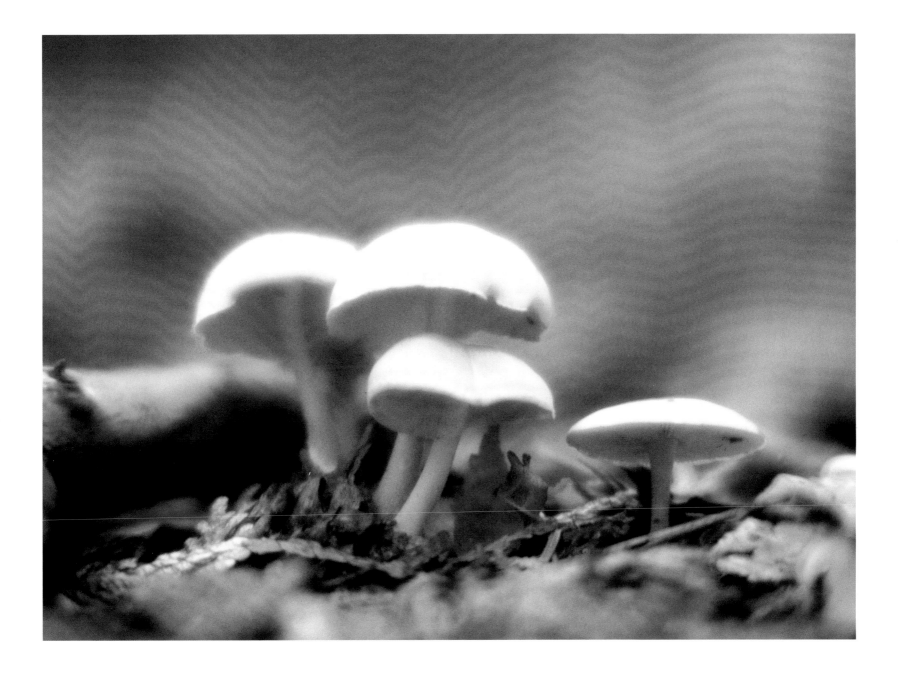

Family of Mushrooms

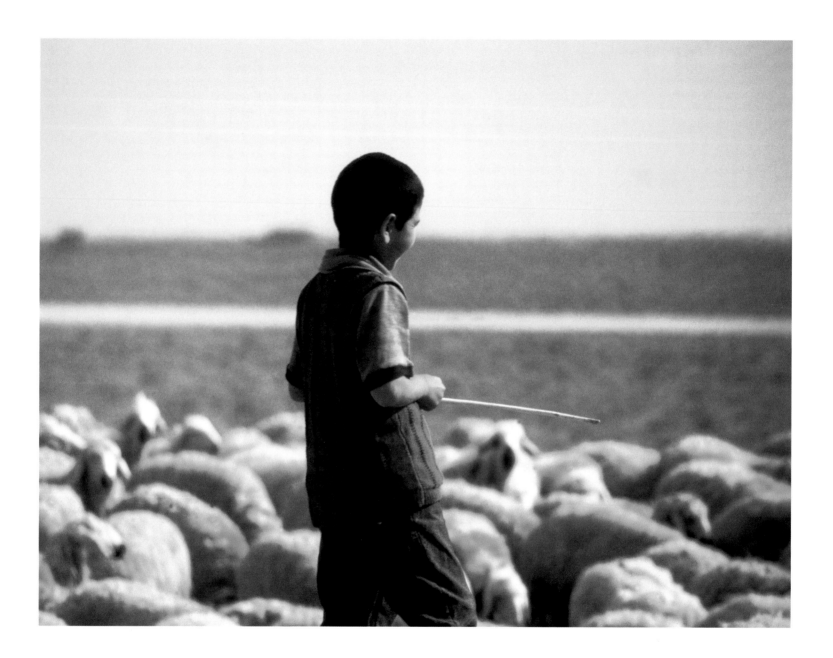

Little Shepherd

Choose a job you love,
and you will never have to work
a day in your life.

—Confucius

Let the beauty we love be what we do.
There are hundreds of ways to kneel
and kiss the ground.

—Rumi

And to love life through labour is to be intimate
with life's inmost secret...And when you work with love
you bind yourself to yourself, and to one another...

—Kahlil Gibran

There is not a short life or a long life.
There is only the life that you have, and the life you have
is the life you are given, the life you work with.
It has its own shape, describes its own arc, and is perfect.

—Greek saying

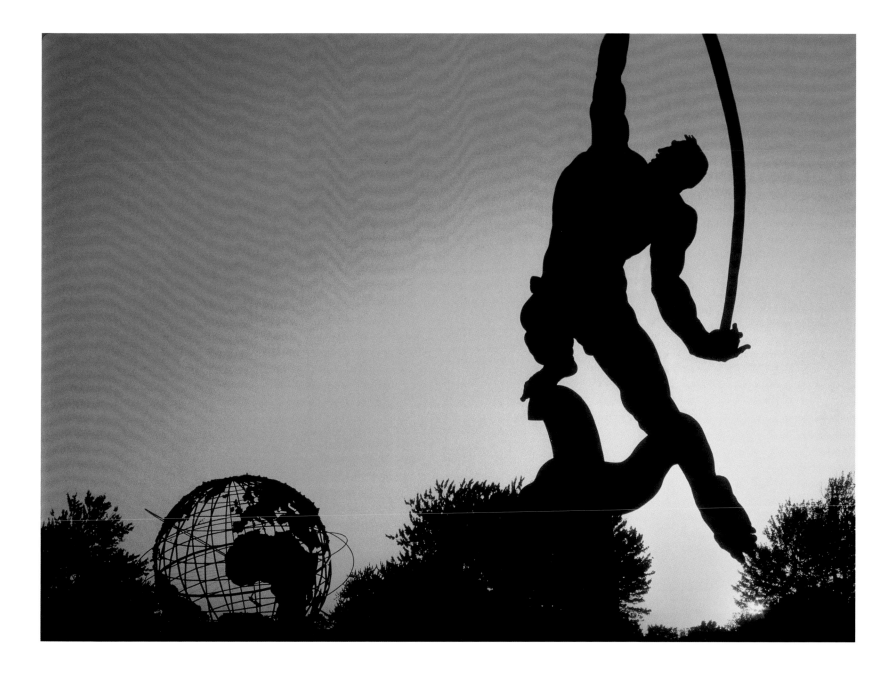

World at a Distance

It is not because things are difficult that we do not dare:
it is because we do not dare that they are difficult.

—Seneca

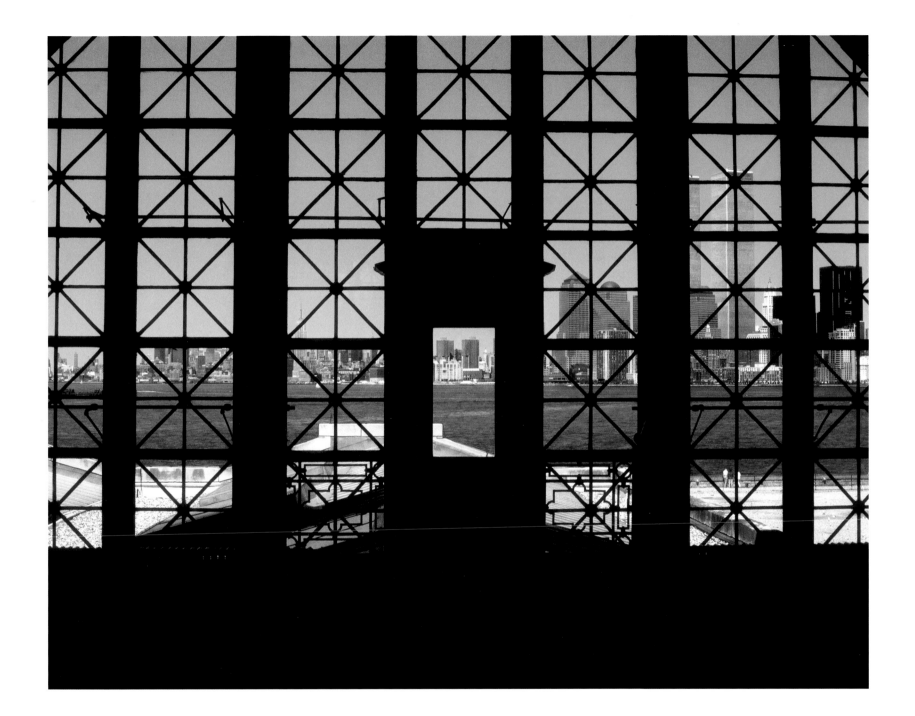

Ellis Island

There is nothing more difficult to take in hand,
more perilous to conduct, or more uncertain in its success,
than to take the lead in the introduction of a new order of things.

—Inscription from Machiavelli's Tomb

Liberty Moving

"The only thing that matters,
my goal, my reward,
my beginning, my end
is the work itself."

—Howard Roark
Ayn Rand's *The Fountainhead*

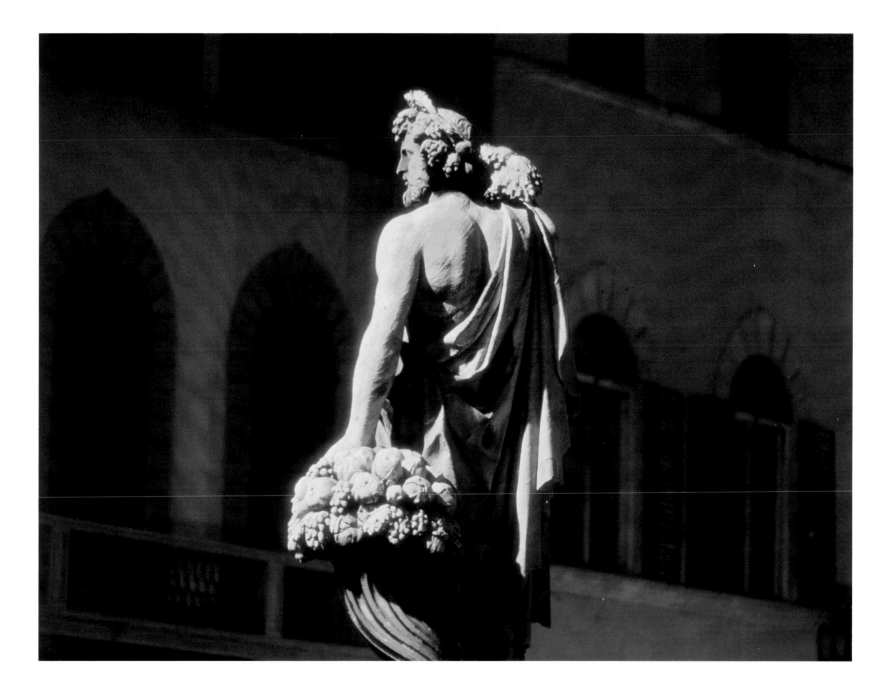

Renaissance Man

Alexander & Bucephalus

The purpose of life is not to be happy.
The purpose of life is to matter, to be productive,
to have it make some difference that you lived at all.
Happiness, in the ancient, noble version, means self-fulfillment,
and is given to those who use to the fullest whatever talents
god or luck or fate bestowed on them.

—Leo Rosten

It is not the critic who counts,

Not the man who points out how the strong man stumbled...

The credit belongs to the man who is actually in the arena;

Whose face is marred by dust and sweat and blood;

Who strives valiantly; who errs and comes short again and again;

Who knows the great enthusiasms, the great devotions,

And spends himself in a worthy cause;

Who at best, knows in the end the triumph of high achievement;

And who at the worst, if he fails, at least fails while daring greatly...

—T. Roosevelt

Falling Greek Soldier

You gain strength, courage and confidence by every experience
in which you really stop to look fear in the face...
You must do the thing you think you cannot do.

—Eleanor Roosevelt

L'Arc de Triomphe

Everything comes if a man will only wait.
I've brought myself by long meditation to the conviction
that a human being with a settled purpose must accomplish it,
and that nothing can resist a will that will stake
even existence for it's fulfillment.

—Disraeli

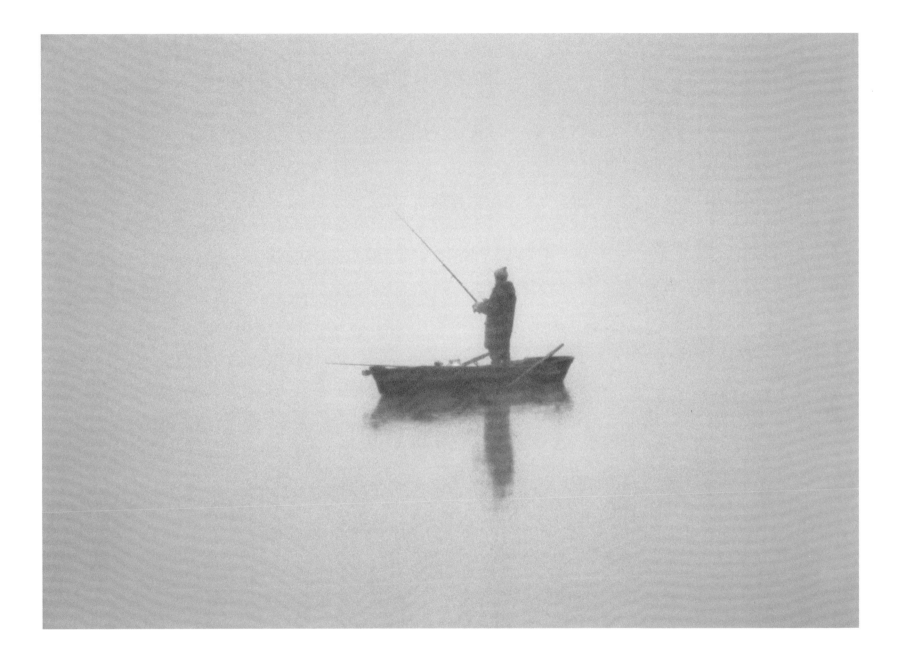

Fisherman

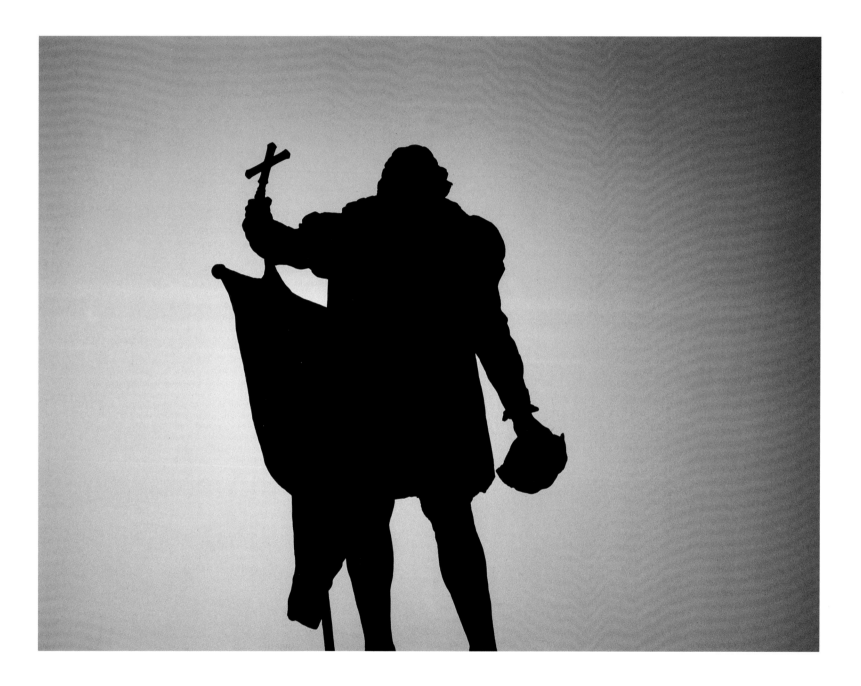

Christopher Columbus

One does not discover new lands
without consenting to lose sight of the shore

...for a very long time.

—Andre' Gide

It may be true that he travels
farthest who travels alone;
but the goal thus reached
is not worth reaching.

—T. Roosevelt

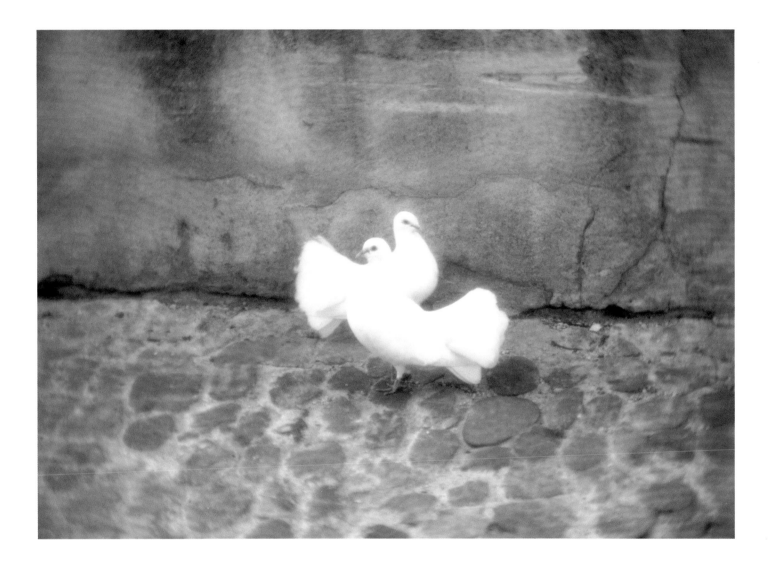

Two Doves, Avignon, France

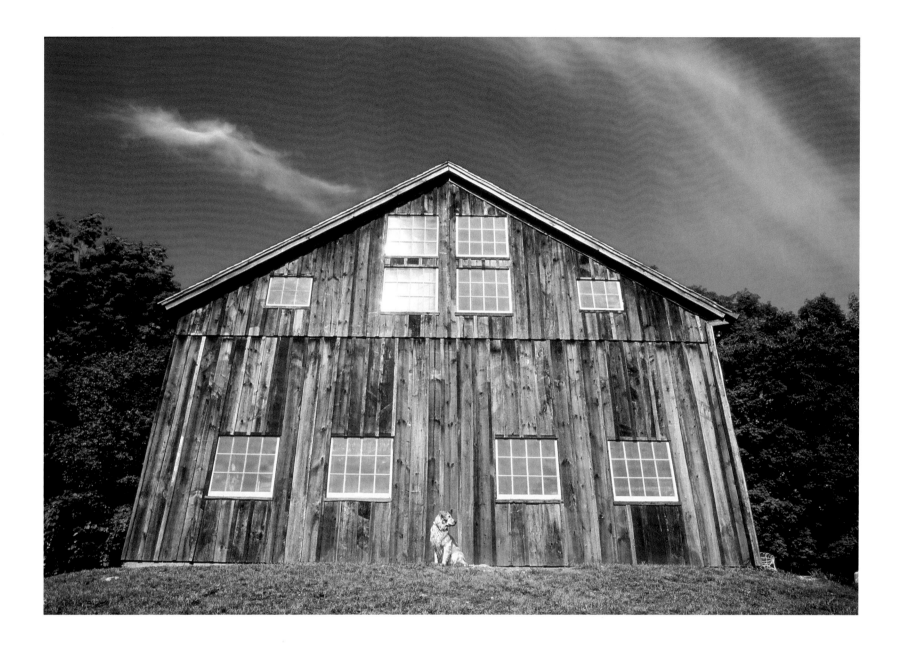

Jezebel's Barn

I said in my heart,

"I am sick of four walls and a ceiling.

I have need of the sky.

I have business with the grass."

—Richard Hovey

I had to go. It was my last chance to be a boy.

—T. Roosevelt

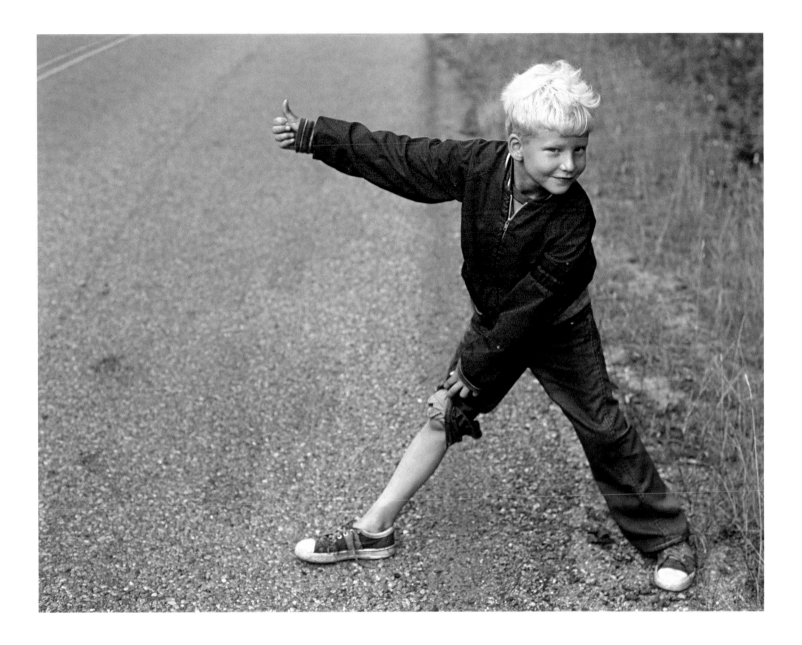

Trevor

If I don't manage to fly, someone else will.
The spirit wants only that there be flying.
As for who happens to do it,
In that he has only a passing interest.

—Rainer Maria Rilke

Mercury on Pegasus

Traveling is a fool's paradise.

We owe to our first journeys the discovery that place is nothing.

At home I dream that at Naples, at Rome, I can be intoxicated with beauty,

and lose my sadness. I pack my trunk, embrace my friends, embark on the sea,

and at last wake up in Naples, and there beside me is the stern fact,

the sad self, unrelenting, identical, that I fled from.

My giant goes with me wherever I go.

—Ralph Waldo Emerson

Theatro Municipal

He who would know the world,

 seek first within his being's depths;

He who would truly know himself,

 develop interest in the world.

—Rudolf Steiner

The World

Ten years' searching in the deep forest.
Today great laughter at the edge of the lake.

—Soen

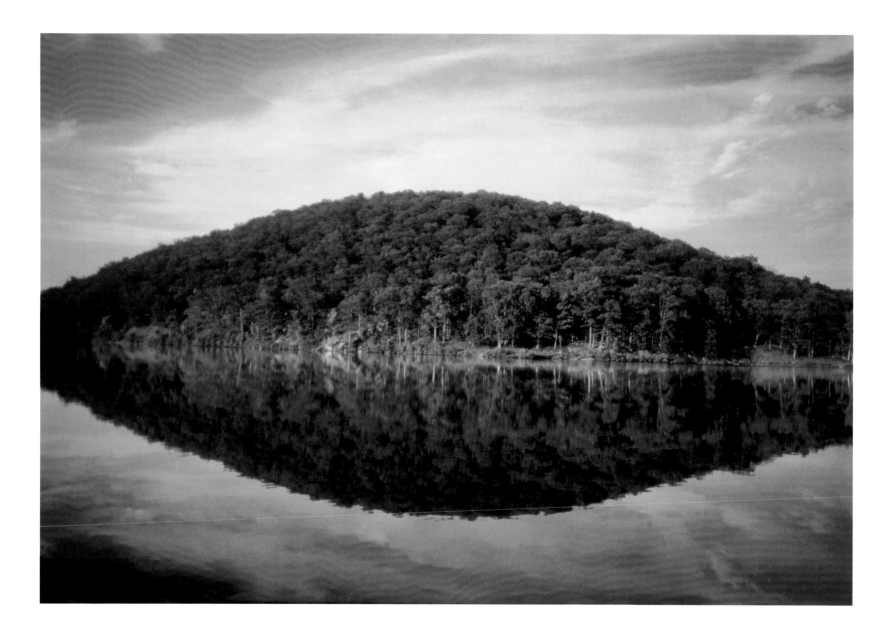

Turkey Lake

Good thoughts
will produce good actions.

—The Buddha

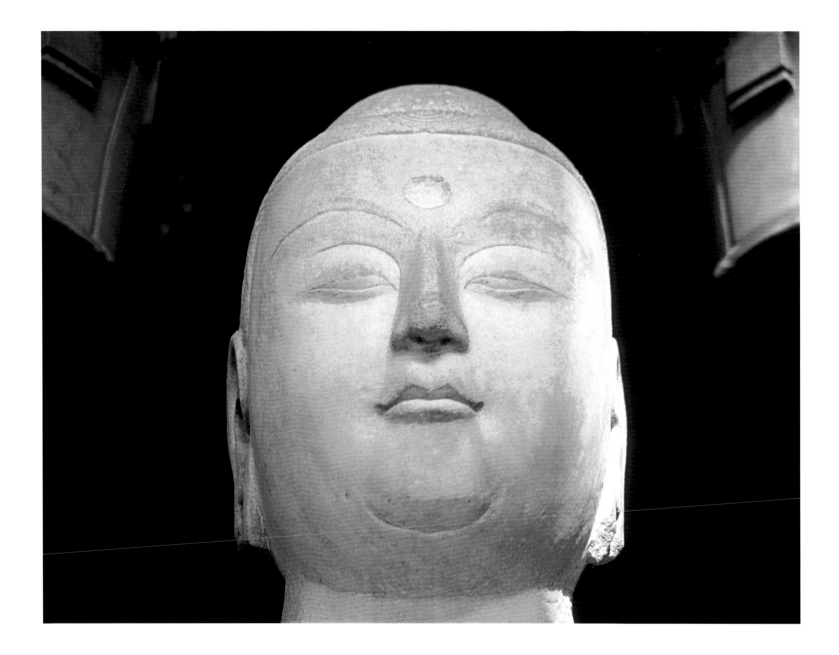

Eyhraune's Buddha

To open our own heart like a Buddha,
we must embrace the ten thousand joys
and the ten thousand sorrows.

—Jack Kornfield

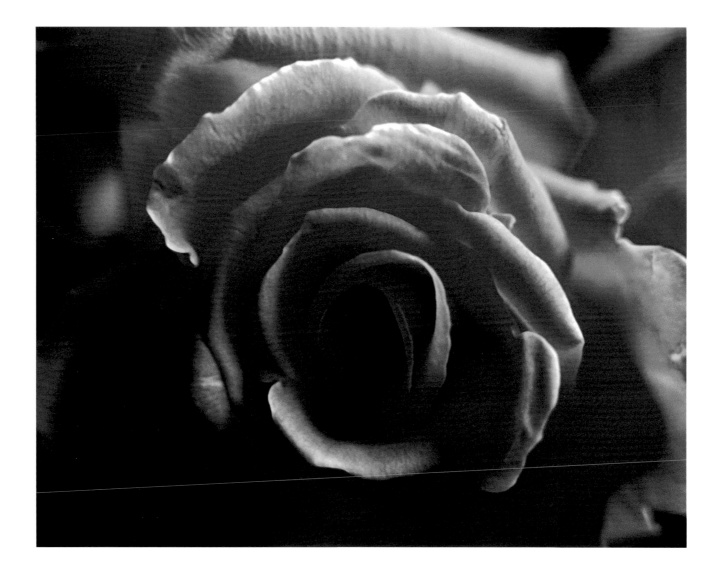

Pink Rose

In dwelling, live close to the ground.
In thinking, keep to the simple.
In conflict, be fair and generous.
In governing, don't try to control.
In work, do what you enjoy.
In family life, be completely present.

—Tao Te Ching

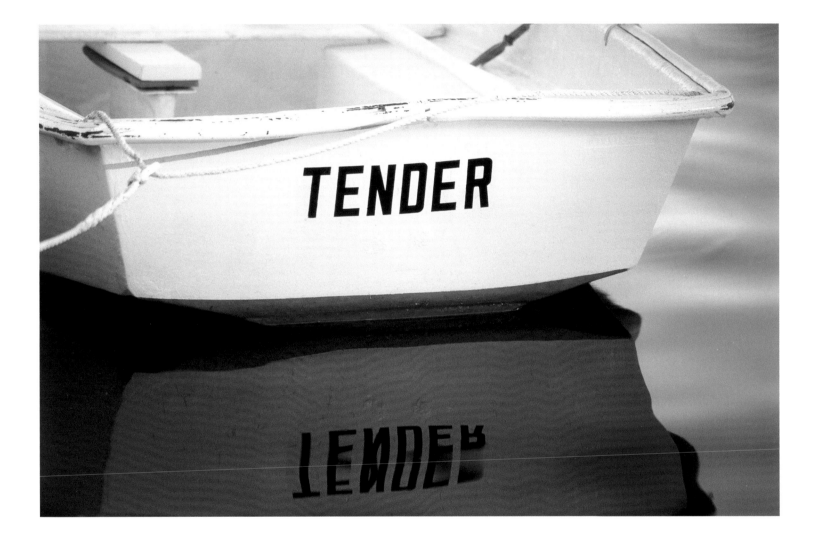

Everything is based on the mind, is led by mind, is fashioned by mind.
If you speak and act with a polluted mind, suffering will follow you
as the wheels of the oxcart follow the footsteps of the ox.
Everything is based on mind, is led by mind, is fashioned by mind.
If you speak and act with a pure mind, happiness will follow you,
as a shadow clings to a form.

—The Buddha

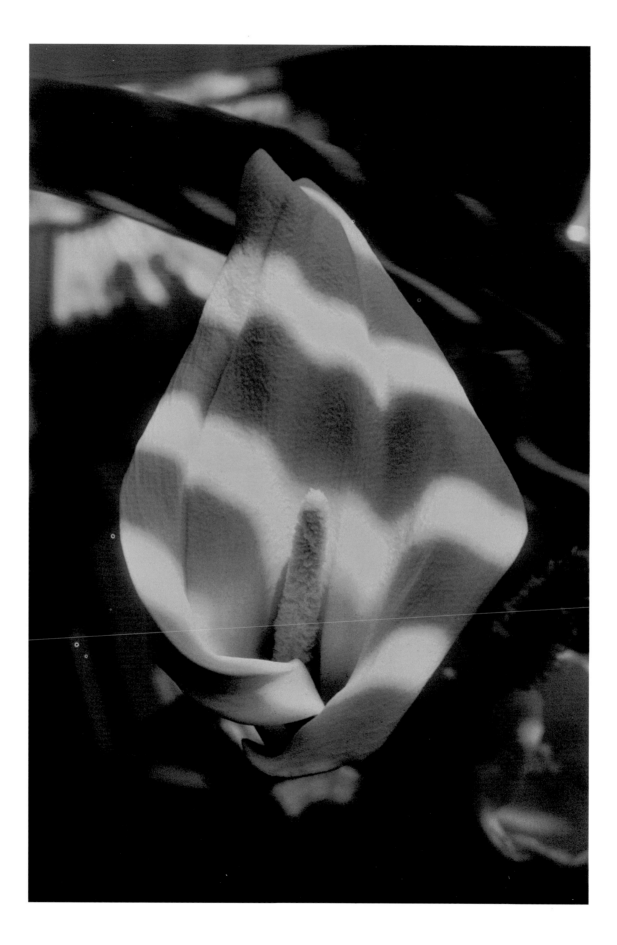

Yellow Calalily

Behavior influences consciousness.

Right behavior means right consciousness.

Our attitude here and now influences the entire environment:

our words, actions, ways of holding and moving ourselves,

they all influence what happens around us and inside us.

The actions of every instant, every day, must be right…

Every gesture is important. How we eat, how we put on our clothes,

how we wash ourselves, how we go to the toilet,

how we put our things away, how we act with other people,

family, wife, work—how we are: totally,

in every single gesture.

—Taisen Deshimaru

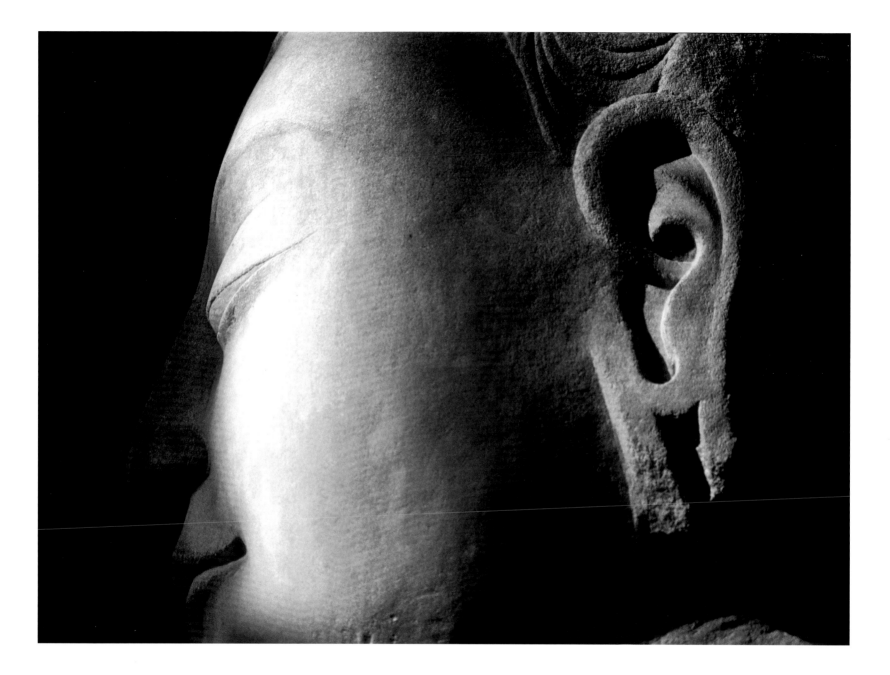

Buddha Listening

Peace of mind produces right values,
right values produce right thoughts.
Right thoughts produce right actions
and right actions produce
work which will be a
material reflection
for others to see
of the serenity
at the center
of it all.

—Robert M. Pirsig

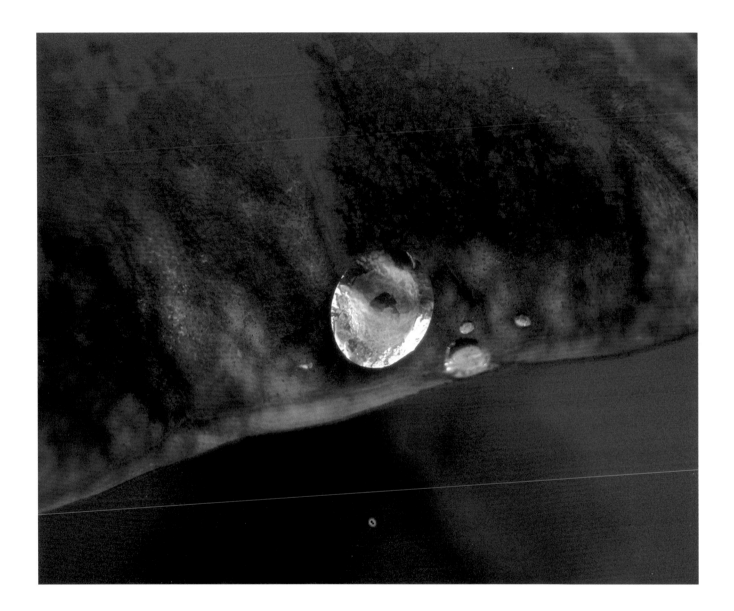

Ho Jo #3

The tree which moves some to tears of joy is in the eyes
of others a green thing which stands in the way.
As a man is, so he sees.

—Blake

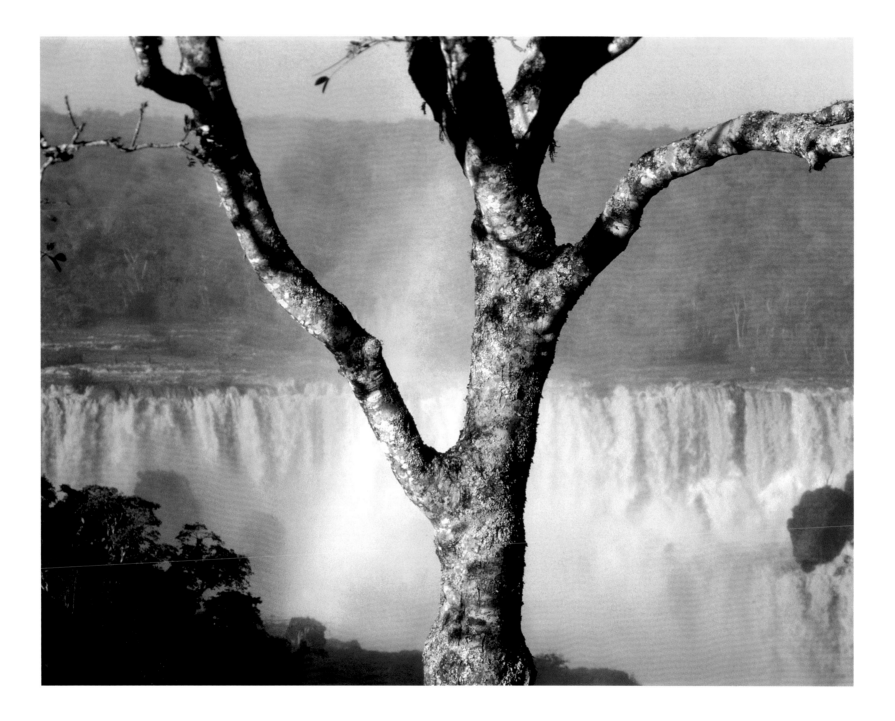

Rainbow Falls

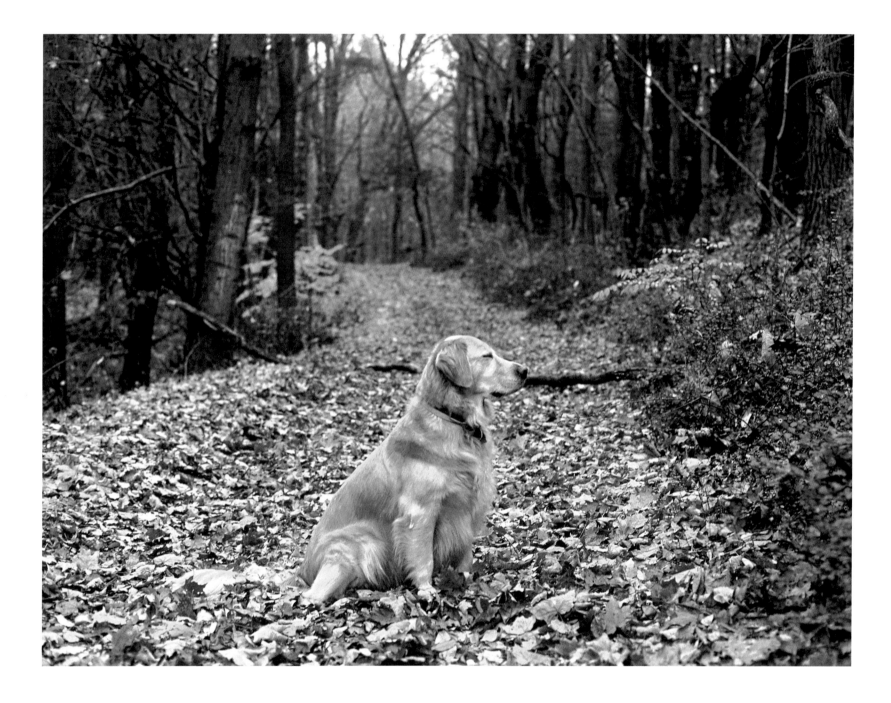

Meditating

You are sitting on the earth, and you realize that this
earth deserves you and you deserve this earth.
You are there—fully, personally, genuinely.

—Chogyum Trungpa

I have been in love with painting ever since I became conscious of it at the age of six.
I drew some pictures I thought fairly good when I was fifty, but really nothing I did
before the age of seventy was of any value at all. At seventy-three I have at last caught
every aspect of nature—birds, fish, animals, insects, trees, grasses, all. When I am eighty
I shall have developed still further, and I will really master the secrets of art at ninety.
When I reach a hundred my work will be truly sublime, and my final goal will be
attained around the age of one hundred and ten, when every line and dot I draw will
be imbued with life.

— Katsushika Hokusai

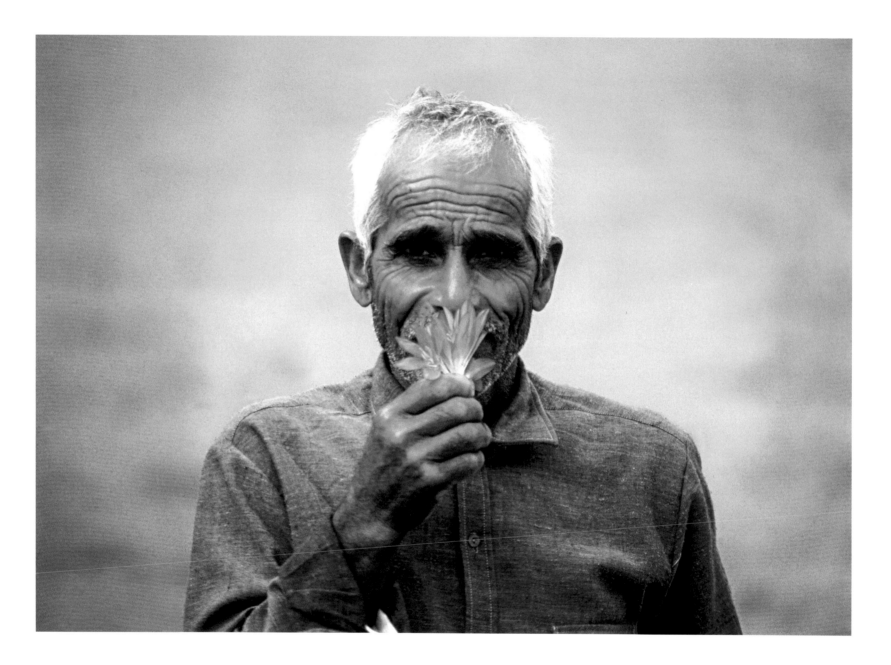

Ramazan's Father

Those who dream by night in the dusty recesses of their minds
wake in the day to find that all was vanity;
But the dreamers of the day are dangerous men,
for they may act their dream with open eyes,
and make it possible.

— T. E Lawrence

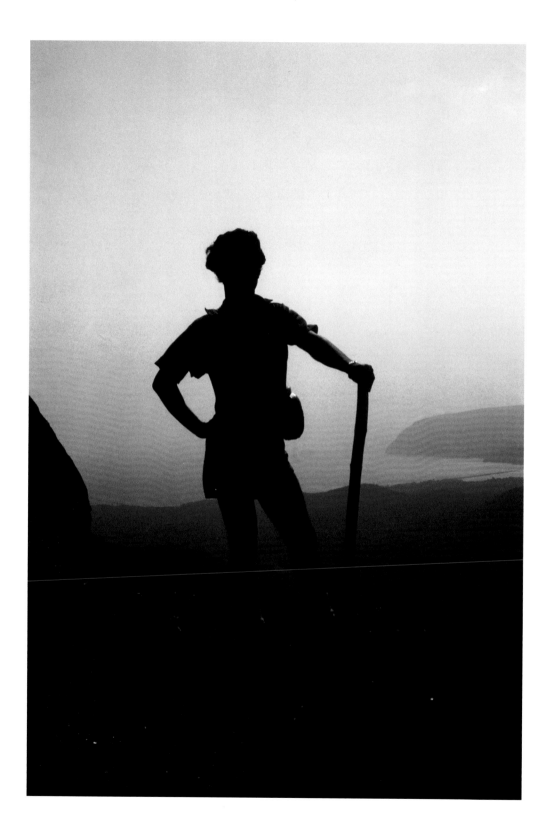

The Hiker

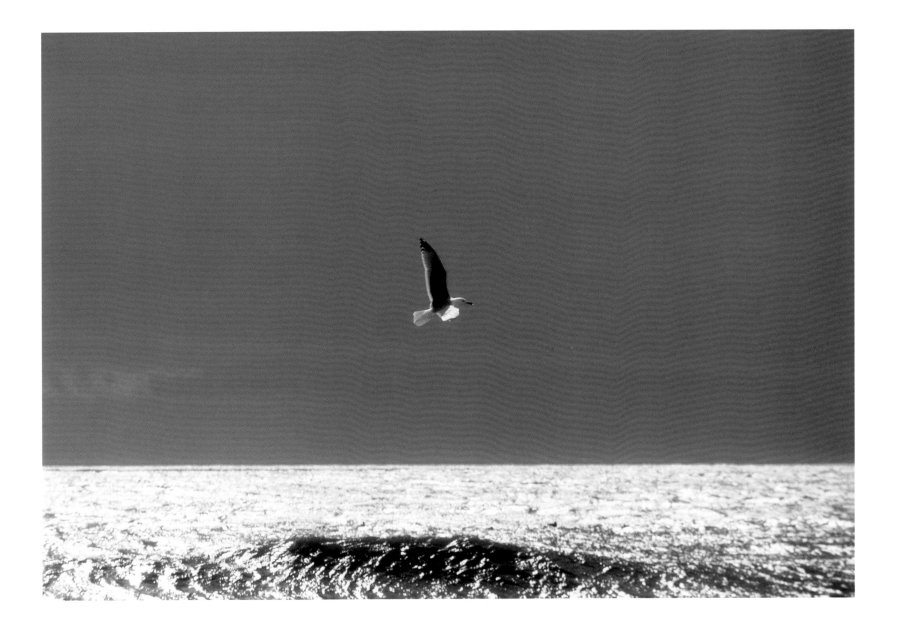

Wings & Waves

Always keep moving
Move to the open space
Be ready for the open pass

—Lino Di Lullo

Look forward, continue to grow.
As long as you live you have a future.

—Boyd

Again and again someone in the crowd wakes up,
he has no ground in the crowd, and he emerges according to much broader laws.
He carries strange customs with him and demands room for bold gestures.
The future speaks ruthlessly through him.

—Rainer Maria Rilke

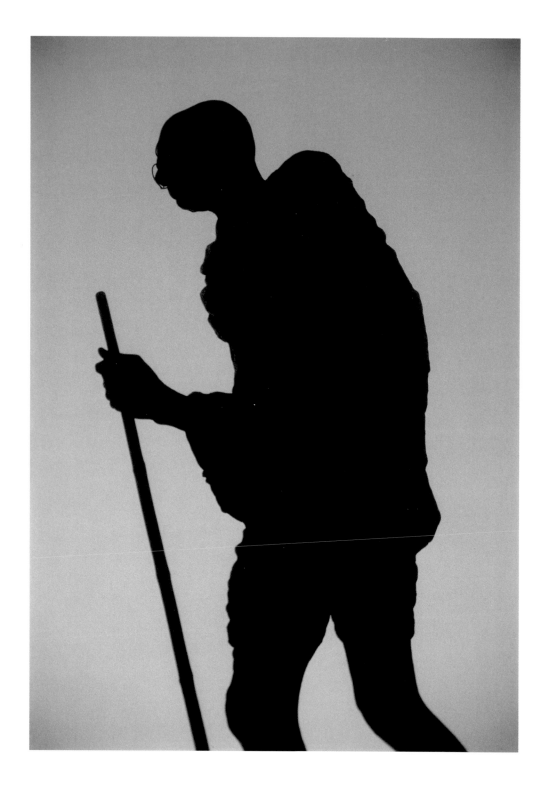

Gandhi of 14th Street

Since life may summon us at every age

Be ready, heart, for parting, new endeavor,

Be ready bravely and without remorse

To find new light that old ties cannot give.

In all beginnings dwells a magic force

For guarding us and helping us to live.

—Hermann Hesse

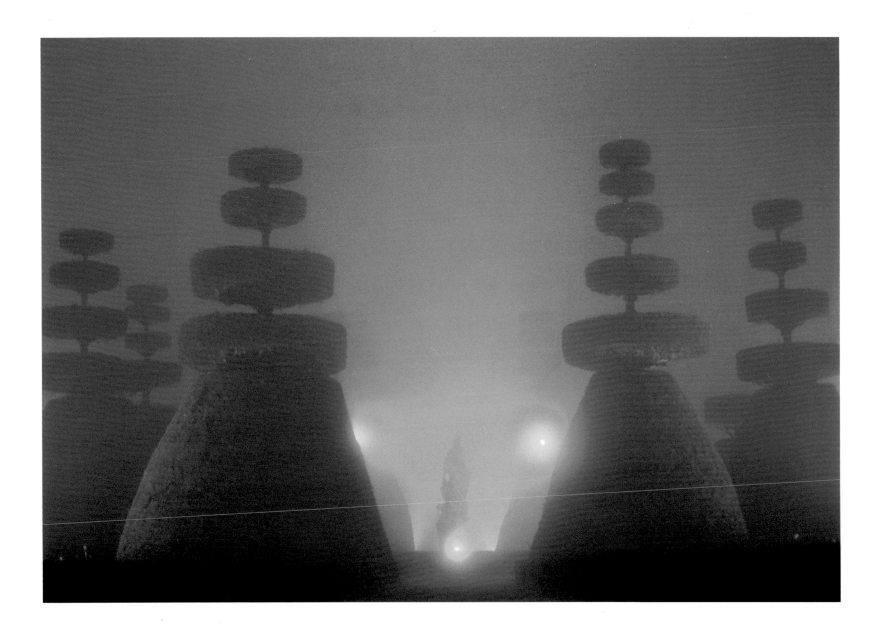

Spiritual Experience

Be patient toward all that is unsolved in your heart

Try to love the questions themselves...

Do not now seek the answers, which cannot be given.

Because you would not be able to live them.

And the point is to live everything.

Live the questions now.

Perhaps you will then gradually without noticing it,

Live along some distant day into the answers.

—Rainer Maria Rilke

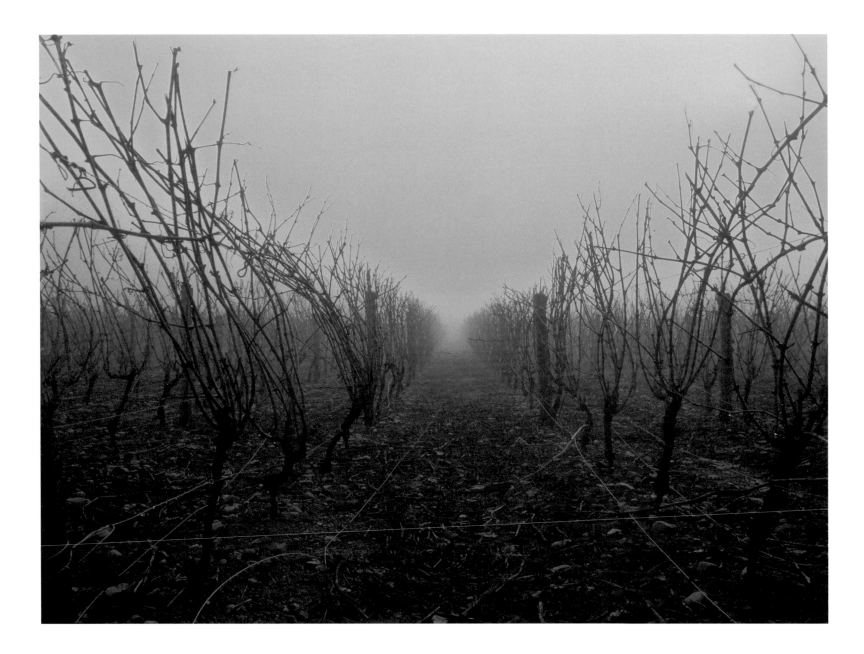

Vineyards

THE MASTER GAME

by Robert S. DeRopp

Seek, above all, for a game worth playing. Such is the advice of the oracle to modern man. Having found the game, play it with intensity—play as if your life and sanity depended on it. (They do depend on it.) Follow the example of the French existentialists and flourish a banner bearing the word "engagement". Though nothing means anything and all roads are marked "no exit", yet move as if your movements had some purpose. If life does not seem to offer a game worth playing then invent one. For it must be clear, even to the most clouded intelligence, that any game is better than no game.

But although it is safe to play the Master Game, this has not served to make it popular. It still remains the most demanding and difficult of games and in our society, there are few who play. Contemporary man, hypnotized by the glitter of his own gadgets, has little contact with his inner world, concerns himself with outer, not inner space. But the Master Game is played entirely in the inner world, a vast and complex territory about which men know very little. The aim of the game is true awakening, full development of the powers latent in man. The game can be played only by people whose observations of themselves and others have led them to a certain conclusion, namely, that man's ordinary state of consciousness, his so-called waking state, is not the highest level of consciousness of which he is capable. In fact, this state is so far from real awakening that it could appropriately be called a form of somnambulism, a condition of "waking sleep".

Once a person has reached this conclusion, he is no longer able to sleep comfortably. A new appetite develops within him, the hunger for real awakening, for full consciousness. He realizes that he sees, hears, and knows only a tiny fraction of what he could see, hear and know, that he lives in the poorest, shabbiest of the rooms in his inner dwelling, and that he could enter other rooms, beautiful and filled with treasures, the windows of which look out on eternity and infinity.

The solitary player lives today in a culture that is more or less totally opposed to the aims he has set for himself, that does not recognize the existence of the Master Game, and regards players of this game as queer or slightly mad. The player thus confronts great opposition from the culture in which he lives and must strive with the forces which tend to bring his game to a halt before it has even started. Only by finding a teacher and becoming part of the group of pupils that the teacher has collected about him can the player find encouragement and support. Otherwise he simply forgets his aim, or wanders off down some side road and loses himself.

Here it is sufficient to say that the Master Game can never be made easy to play. It demands all that a man has, all his feelings, all his thought, his entire resources, physical and spiritual. If he tries to play it in a halfhearted way or tries to get results by unlawful means, he runs the risk of destroying his own potential. For this reason it is better not to embark on the game at all than to play it halfheartedly.

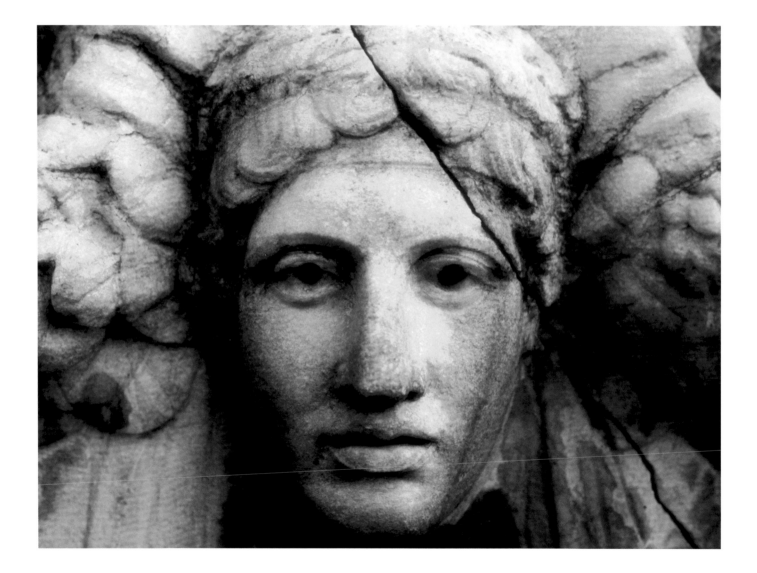

Two Faces

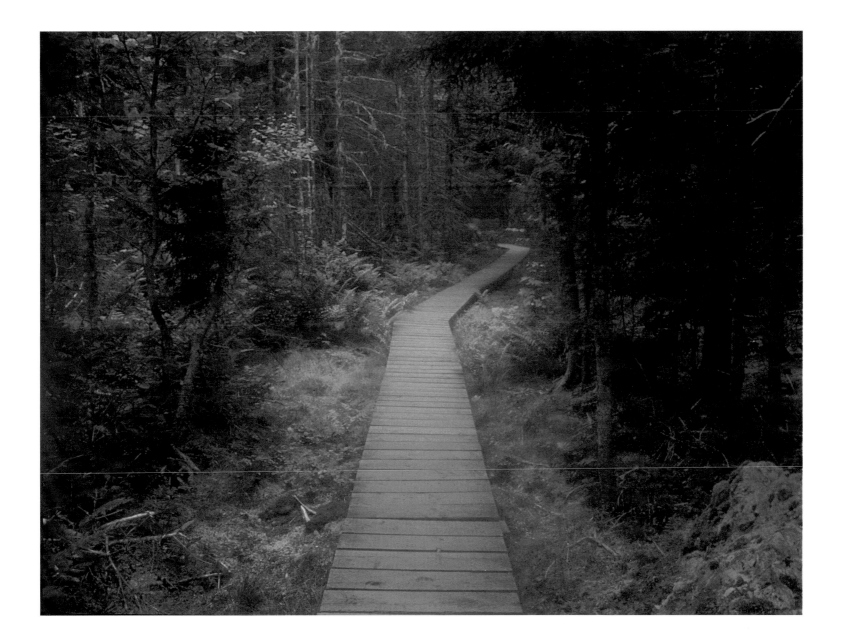

Turning Point

There were people instrumental in facilitating the turning points in my life. Each of these people made an enormous gift to me in my personal life and career:

Fitz Heinz
Joe Garcia
Warren Crow
Robert Shaffer
Steven Hart
Vince Mauro
Ralph Hall
Mertash Khomarlou
Ipek Duben
John Caputo
Ellen Flowers

To Paul Weinschenk, owner of Clone a Chrome, for his guidance and support of my career. To the staff, past and present, for making exquisite Cibachrome prints.

Alvaro Charcas,
Mei Li
Francis Perry
Rich Rudiander
Tomak Trzesniewski
Rene Vera
Lloyd Williams
Piotr Wojciechowski

To Peter Lukic, my partner on this ongoing project in the graphic design, marketing and great support over the past 5 years.

To my parents John & Mary Gagliardi whom I will always love dearly. With them there have been important turning points, and from her I am still learning patience.

To Madalasa Mobili—thank you for your precious contribution to this book.

To everyone who taught me to play soccer, including: Glenn, Dragi, Kevin, Richardo, Tony & Lino

To the great people who worked closely with me giving their time, energy, and creative input:

Lise Bjerkedok
Elaine Bowlby
Paulo De Freitas
Alp Ergen
Mark Hall
Maya Hedstrom
Judy Herman
Birnur Itil
Elizabeth Kolts
Eric Laxman
Carter LeBlanc
Irem Levend
Mitra Martin
Elke Parva
Ali Sarikaya
Ayse Sener
Marina Soloviova
Edwin Vicente

Especially to Cemil Aydogan, for his many years of work, friendship, support, and the overall calming effect he has had on me.

To the people who supported my photographic career, and to the people whose names I did not get to know or may have forgotten:

Debbie Altdoerffer
Wayne Allen
Bob Altavilla
Howard Amchin
Kenneth Andrews
Robert & Lynne Angelicola
Martene Antill
Joan Asher
Bob Attridge &
 Doreen Van Patten
Michael Austin
Avi
Aileen Balitz
Ernestine Banach
Bob Bardach
Barbara Barkley
Annette Barone
Ellen Bartoldus
Timothy Bartos
Maris Bates
Jerry Baden
Bill Bayers
Dr. Ester Benenson
Robert & Denise Benmosche
Janet Bennett
Beverly Bennis
Denise Berger
Naomi Berger
Steve Bergstraesser
Arnold Berkovits
Paul Bernhardt
Martha BilManevich
Brian Birch
Barbara Blackstone
Sister Deborah Blados
Mary Ellen Bloodgood
Regina Bonacci
Marie Bonapace

Richard Bouffard
Elaine Bowlby
Kurt Boxberger
Gary Breuilly
Kenn Brown
Kathy Bufano
Roz Burak
Caitlin Burck
Amy & Steve Burke
Tom Bush
Ruth Callahan
Barbara & Mark Cane
Shirley & Marvin Caro
Ken Carter
Oscar Carter
Susanne Casal
Donna Chambers
Judith Champion
Kris Cittadino-Marriott
Gultekin Cizgen
Darleen Clements
Brenda Cobane
Richard Codanti
Helen Cohen
Lynn Collinson
Janet Conrad
Sharon Cook
Oscar Correale
Deirdre & Geoff Cox
Cathy Cully
Nancy Cummings
Jay Daitchman
Judy Dalseid
Monica Dalton
Pat D'Auria
Myles Davis
Ben DeGiulio
Karen Delgado
Michael & Maggie Delia
Joseph DeLucia
Michael Demisay
Esra Dereli
Susan deRose

Emma & Robert DeVito
Mary Devlin
Susan DiMotta
Marty Doverspike
Michael Dreisiger
Michael Driscoll
Barbara Drosman
Scott Drucks
Tana & Don Dryden
Craig Duncan
Jack Dunnigan
Dr. Harry Dweck
Martin Ehrlich
Lucienne Errie
Joseph Esposito
John Farling
Mellissa Farnscomb
Michael Fassler
Laura Fasulo
Eli Feldman
Lowell Feldman
Cheryl Fine
Laura Finestone
Harvey Finklestein
Jack Finn
Sister Catherine Firotnak
Marvin Fischer
David & Paula Fishman
Mark Flashen
Ronda Flashen
George Fleming
Lara Flynn-Boyle
Warren & Carole Frank
Marjorie Frank
Wenda Focke
John Footman
Bill Forman
Ingrid Fox
Scott Freeman
Herb Friedman
Cynthia Fuccillo
Ann & Richard Fudge
Nancy Gallagher

Marie & Nino Galastro
Joe & Mary Anne Galea
Debbie Garron
Teddy Gardner
Bob Gaudreau
Kenneth Gaul
Lorraine & Richard Gardos
Raymond Garrett
Linda Gayton
Bruce Gendron
Esperanza Gerardi
Chris Giampocaro
Dan Giannini
Bill Gilbert
Clari Gilbert
Robert Gilpatrick
Lynn Giuliani
Annemarie Gleason
Irwin Glenn
Bob Glock
Jackie Goldberg
Lorraine Goldman
Brad Goodwin
Bob Gorton
Kara Goudie
Patrice Goulet
Gary Granoff
Mary Gray
Robert Gray
William Green
Harris Greenberg
Chuck Greenblatt
Dale Greenwald
John Gregory
Bill Gross
Nancy Hadley
Larry Hammer
Tony Hammer
Kate Hannenberg
Khemraj (Dennis) Hardeen
Cleve Harp
Norah Hart
Wendy Harvey

Anthony Hatziioannou
Irene Hawkins
Patti Hays
Anne Hedderich
Jim Heinz
Adele Herman
Harvey & Elaine Herman
Josselyne Herman
Mitch & Catherine Herman
Barbara & Jonathan Hodosh
Scott Hoffman
Jimmy & Kelly Yu Hong
Matt Hudson
Ken Hugo
Bruce Hutchinson
Patrick Huther
Patrick Hurley
Rick Ianello
Anthony & Rosemary Iannitelli
Mary Icaza
Filiz Inal
Eyhraune Jau Saune
Debbie Jeffery
Dennis Johnson
Pete Johnson
Charles Johnston
Tony Joseph
Donna Joyce
Eric & Sherry Kalt
Malcolm Kanter
Harry Karten
Mark Kator
Linda Kelly
Ned Kelly
Peter Kelly
William Kennedy
Mary Kenny
Rao Khan
Karamah Khashiun
Dr. Khaski
Nick Kilanowski
Alex & Silva Kilercyan
Dr. Tom Kilgannon

Ballie King
Pam Kingsbury
Frederic Klein
Roxanne Klinger
Ray Klocek
Father Robert Kloster
Richard Kohlhausen
David Kopelman
Jonas Kover
Lee Kowalsky
Leon Kramer
Patricia Krasnausky
Camilla Kvietok
Anne Lucie Lamarre
Robin Landow
Rita Landy
Sue Lang
Mary Jean Laraway
Jylle Lardaro
Mark Larsen
Linda Laucirica
Susan Laughter
Bernice Leader
Pat Leddy
Marilyn Leffers
Amy Lehman
Gary Lelli
Yuki Lemarr
Ira Levy
Gail & Gary Libertoff
Ed Lieberstein
Joanna Lines
Leslie Link
Neil Lippin
Debora Lipsen
Michael Lohneiss
Beth Lucey
Sarah & James Luchansky
Deborah Ludorf
Donald & Grace Luneburg
Gerald Luss
Gerald Lutzer
Carol MacDonald

Ed MacFadden
Dennis Magid
Danai Maloff
Orlando Maione
Richard Maloney
S. Mano
Melanie Marraffa
Mary Marciniak
Susan Marcotullio
Joe Marino
Father John Paul Mario
Matthew Mark
Marilyn & Marvin Markman
Sharon Markowitz
Lisa Marrello
Kris Marriott-Cittadino
Patrick Martone
Sister Cecilia Mary
Beverly Masiello
Richard Massa
Carmen & Amy Mazzotta
Frank Mazzotta
Lillian & Carmen Mazzotta
Chantey McBride
Mark McGinley
Leonard & Cecile McIntosh
Nancy McNeilly
Jeff Mear
Dr. Allen Meek
Elliott Meltzer
Jake Meltzer
Nancy Meltzer
Alton Mendleson
Kenneth Meredith
Helene Meyers
John Midgley
Hope Miller
Patricia Miller
Gregory Mink
Helen Miskimmons
Andy Mitchell
Juan & Sergio Mobili
John & Marsha Monro-Wright

Nancy Montgomery
Rita Morgan
Susan Morgan
Joel Morris
Loretta Morrone
Inez Murphy
Glenn & Laurie Mutchler
Ray Napolitano
Steve Nelson
Joan Nicol
Elena Nogueira-Lopez
Dana Nolan
Steve Noring
Sister Paula Notarthomas
Judy Nunn
Sister Sean O'Brien
Ray & Suzie O'Connor
Sebnem Olsen
Clifford Osinoff
David Packer
Bruce Paler
Cliff Palmer
Chris Palmieri
Bert Paolucci
Keith Parker
Dr. Mariam Parker
Marjie & Chuck Parrot
Albert Pasinella
Dr. John Passarelli
Patti Patti
Joan Pease
Tim Peck
Stu Penney
Charles Peters
Kimberley Phillip
Robert Pilla
Jim Pike
Donna Polsinelli
Amy Pressman
Dr. George Pringle
Mario Prividera
Patricia Pyle
Kathy Raber

Rich Racosky
Aida Ramos
Fred Randall
Ralph Reid
Ray Reisert
Kristin Reyers
Mary Monica Riley
Neil Roberts
Pat Rockwell
Dorian Romer
David Rose
Dr. Bruce Rosen
Ann Rosenthal
Jane Rosenthal
Johanna Ross
Felicia & Aaron Rubin
Lee Rubin
Michele Ruggiero
Larry Rybak
Jennifer Sable
Mike Sacca
Leslie Salant
Tony Salerno
John Samuels
Betty Sarmiento
Phyllis Satin
Sharon Saunders
Lenore Scendo
Laura Schachter
Abe Schanzer
Joseph Scharf
Alex Schlossberg
Manny & Joanne Schmaizl
Debbi Schonberger
Selma Schoolman
Daniel Schunkewitz
Debbie Schwartz
Steve Seidmond
Joe Seminaro
Phil Senechal
Nevval Sevindi
Peter Shaffer
Diana Shear

Gail Shephard
Gina Simpson
Howard Slater
Larry Slatky
Alvan Small
William T. Smith
Chuck Smith
Dennis Smith
Richard Smith
Tony Smythe
Linda Snowberger
Melanie Sobash
Paul Soper
Bonnie Sorman
Jerry Spaziani
Skye Spiegel
Orlando Springs
Betsy Stack
Doris & Timothy Steffens
Kevin Steffens
Timothy Steffens II
Ed Stevens
Sean Stockmeyer
Mary Szarejko
Pat Taylor
Bruce Tanner
Barry Taratoot
Krista Taskey
Pat Taylor
Paul & Debbie Tenis
Jean Thompson
Katherine Ticer
Richard Tileareio
Chuck Tomaselli
Larry Trivieri
Nancy Tucker
Iris Valdez
Linda Van Alstyne
Jorge Vazquez
Colleen Velten
Susan Vittorio
Ellen Walker
Cynthia Wallace

Kathryn Wallachy
Laurie Walters
Patty Weiner
Arthur Webb
David Webb
Brian Weld
David Weinstein
Gayle Weinstein
Deborah Wilde
Bruce Willis
Rick Wilson
Noreen & Peter Wistreich
Paul Witte
Bob & Randi Wolchok
Danny & Henry Woltag
Joseph Woods
Barbara Wright
Sister Xavier
Peter Young
Roger Yurko
Maureen Zagami
Bernie Zatz
Gary Zausmer
Carol Ann Zeidler

**To the businesses who have
supplied me with the materials
and services that have enabled
me to do my work:**

A&R Framemakers,
Charrette Corporation
County Frame
Decor Moulding
Dennis Laminating
Dezer Properties
Emulsion Photo Lab
Frameware
Kodak
L.T.I. Photo Lab
Metro Frameworks
Midgley Printing

Steve Saltman
S.M.P. Digital Graphics
Studio 70
Travel Visions

**To the organizations, businesses,
and architectural and design
firms who have both collected
my work, and represented me
to their clients:**

Aging In America
Albank
Albany Guardian Society
Almost Family
Amalgamated Bank
A. M. I.
Arbor Hill Living Center
Arcade Booksellers
Arthur Schuster Inc.
Art Plus
ATT International
Augustana Lutheran Home
Avery Heights
Baptist Retirement Center
Barton Protective Services
Beechwood Retirement Center
Bennett Sullivan Associates
Beth Abraham Health Services
Beth Israel Hospital
Bill Gross & Associates
Birchwood Nursing Center
Bishop Hucles Episcopal Home
Broadlawn Manor Nursing Home
Bronx Lebanon Special Care Ctr.
Brookdale Hospital
Cabrini Center for Nursing
Castrol Corporation
Center for Nursing &
 Rehabilitation
Central Mortgage Brokerage Corp.
Central New Jersey Jewish Home

Central N.Y. Assoc. For The Blind
Centrex Clinical Labs
Child's Nursing Home
Ciba Special Chemical
Charles Sitrin Health Center
Charter One Bank
C.M. Capital
CNR Health Care Network
Coler Memorial Hospital
Columbia Green Medical Center
Concord Nursing Home
Corporate Interiors
Daughters of Jacob Geriatric Center
Daughters of Sarah Nursing Center
Davis, Brody & Associates
DeGiulio Associates
DiMella Shaffer Associates
Dr. Robert Yeager Health Center
Dr. William Benenson Pavilion
Dormitory Authority of New York
Dryden Gallery
Eastern Star Home
Eddy Cohoes Rehabilitation Center
Eddy Memorial Home
Eden Park Residential Facility
Eger Lutheran Home
Egner & Associates
Ellis Hospital
Englewood Hospital
Faxton-St. Luke's Health Care
Field Home Holy Comforter
Fleet Bank
Folts Home
Forty Five Ten
Frank & Marcotullio Design
Freelance Cafe
Fulton County Healthcare
Go For Baroque
Gorton Associates
Granoff & Walker Esq.
Gurwin Jewish Geriatric Center
Hallmark Nursing Center
Harza Engineering

Health Care Associates
Health Furniture & Design
HealthTrac
Heritage Healthcare
Hitachi America
George Hodosh & Associates
Holly, Wood, 'n Vines
Holy Family Home
Hospital for Special Surgery
H.Q. Headquarters
Hudson House
Isabella Geriatric Center
Jewish Home for the Elderly
Jewish Home of Central N. Y.
J.M.W. Consulting
K&A Services
Keplers Books
Kilsby Design
Kings Terrace Nursing Home
Knowledge Transfer International
Kwik Kopy
LaGuardia Hospital
Lakeview Lodge
Landow & Landow Architects
Larsen Shine Ginsberg
Laurel Gardens
Lighthouse Financial
Long Island Eye Surgery Center
Loretto Utica Center
Lutheran Medical Center
Magpie
Margaret Tietz Center
Marjorie Doyle Rockwell Center
Martin Lutheran Court
Mary Manning Walsh Home
McNeilly & Associates
Menorah Home & Hospital
Mohawk Valley Nursing Home
Monsignor Bojnowski Manor
Morningside House
Mosaico Restaurant
Mutchler Chemical Company
Nameaug Medical Center

Nathan Miller Center
Navesink House
NCS Healthcare
Newfane Health Facility
New York State Veterans Home,
 Batavia, Oxford & Montrose
North Atlantic Instrument
North Shore Health Systems
North Shore Psych. Consultants
Notre Dame Convalescent Home
Nyack Hospital
NYC Health & Hospital Corp.
Office Furniture Express
Omnibox Incorporated
Oneida Healthcare Center
Orange County Health Care
Ozanam Hall Nursing Center
Packer & Associates
Paine Webber Funding
Partners in Planning
Perkins & Eastman Architects
Pfiser Incorporated
Phoenix Contract Inc
Pickwick Books
Presbyterian Home
Pressman Design Studio
Progress of Peoples Development
Professional Placement
Professional Services
Queen of Peace Residence
Regus Business Centers
Roberts Office Interiors
Rockwell Group
Salvage Management
Sarah Neuman Nursing Home
Savings Bank of Utica
Schunkewitz Partners
Scleicher-Soper Architects
Sedoni Gallery
Shorefront Jewish Geriatric Center
Shoreview Nursing Home
Silvercrest Extended Care Facility
Skidmore Owens & Merrill

Sloan Kettering Memorial Hospital
South Side Hospital
Space Age Aviation
Speaking of Art Ltd.
Sterling National Bank
St. Cabrini Nursing Home
St. Camilius Health Center
St. Lukes Roosevelt Hospital
St. Mary's Catholic Home
St. Peter's Hospital
St. Vincent De Paul Residence
St. Vincent's Medical Center
St. Vincent's Hospital
Suite Solutions
Sunharbor Manor Nursing Center
Sunnyview Rehabilitation Center
Syosset Hospital
The Dolphin Bookshop
The House of Good Shepherd
The Jewish Home and Hospital
The Open Book
The Pegasus Group
The Rebecca Collection
Time to Read Books
Totalkare of America
Tri-State Auto
Truelove & Maclean
United Presbyterian Residence
University Hospital at Stonybrook
Utica National Insurance
Village Care Of New York
Village Nursing Home
Wartburg Lutheran Services
Waterview Nursing Center
W.B. Wood Integrated Interiors
Wellesley Booksmith
Wendy Gee!
Wesley Health Care Center
West Hudson Hospital
Westchester Medical Center
Whidden Silver Design
Woodmere Adult Center
Youville House

Follow your desire as long as you live;
do not lessen the time of following desire,
for the wasting of time is an abomination to the spirit.

—Ptahhotpe 2350 B.C.